IMAGES
of America

LYNN IN THE VICTORIAN ERA

IMAGES
of America

LYNN IN THE VICTORIAN ERA

Diane Shephard for the Lynn Museum

ARCADIA

First printed in 2002.

Published by Arcadia Publishing,
an imprint of Tempus Publishing, Inc.
2A Cumberland Street
Charleston, SC 29401

Printed in Great Britain.

Library of Congress Catalog Card Number: 2002110809

For all general information contact Arcadia Publishing at:
Telephone 843-853-2070
Fax 843-853-0044
E-Mail sales@arcadiapublishing.com

For customer service and orders:
Toll-Free 1-888-313-2665

Visit us on the internet at http://www.arcadiapublishing.com

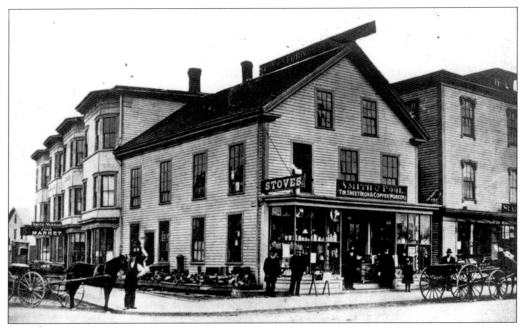

As Lynn celebrated the 250th anniversary of its settlement, it was on the verge of its greatest period of growth, both in industry and population. The Smith and Varnum Fish Market and Smith and Pool copper workers at the corner of Essex and Sutton Streets were among the many hundred small businesses that flourished as a result of this growth.

CONTENTS

ACKNOWLEDGMENTS

The Lynn Museum is grateful to the following individuals who have been instrumental in providing the wonderful images reproduced in this book: Norma Jean MacDonald, granddaughter of Ezra Fraser; Marilyn Bell of the provincial archives of Prince Edward Island; museum board members Bill and Marilyn McGuinness and Sheila Belliveau; former museum president Bill Conway; and Scott and Paula Hamilton.

INTRODUCTION

The Ezra Fraser Collection

In the summer of 2000, the Lynn Museum received a donation of both singular importance and intriguing history: a collection of more than 170 glass-plate negatives, formerly the property of Ezra D. Fraser of North Lake, Prince Edward Island, Canada. Fraser's surviving children had donated the collection to the provincial archives in Charlottetown, believing them to be local scenes. Upon further examination, however, the images were discovered to be not of Prince Edward Island, but of Lynn, Massachusetts, where Fraser was known to have lived and worked as a young man. While many of the photographs had not been seen in Lynn in more than 100 years, a significant portion had appeared in the souvenir book *Photographic Views of Lynn with Historical Sketches from 1629 to 1879.*

Photographic Views was published in 1879 for the 250th anniversary of Lynn's settlement, and the photographs were attributed to Charles E. Cook, a photographer who was active in Lynn in 1879 and 1880. The volume is actually quite short on history and very long on advertisements, including many for businesses appearing in the Fraser collection. Josiah Heal, a grocer of seemingly modest means, published the work in part as an elaborate advertisement for the sale of his business, which he planned to abandon in order to go West. Besides possessing "first-class fixtures for Grocery, Provision and Meat Business," Heal was also the sole agent in Lynn for a number of varied items, including "Howard's Patent Improved Hairbrush" and, more importantly, *Photographic Views.* His claim to "have on hand all the Negatives of the Views in this book and over 500 other" further complicates the question of original ownership of the glass plates in the Fraser collection.

Family history states that Fraser had a studio at 567 Washington Street in Boston, but although several photographers did in fact work at the address, Fraser's name was not among them. Indeed, Fraser was never listed in any Boston or Lynn city directory during the 1870s or 1880s. This absence, however, does not disprove family tradition. Both Boston and Lynn had large "floating populations," and Fraser, a man in his 20s at that time, would have been very typical of the majority of the "floaters." The fact that he traveled back and forth to Canada with the cumbersome glass negatives and then retained them until his death suggests that he was intimately involved in their creation. Evidence depicted in the photographs is sufficient to date the images between 1879 and 1881, precisely the years when family history places Fraser in Lynn, although his connection to Cook remains unclear.

Lynn in 1879

The 250th anniversary of the settlement of Lynn gave a natural opportunity for both celebration and reflection. Memoirs, souvenirs, and histories of the time provide a rich source of information with which to place the Fraser collection in context.

The late 19th century was a period of rapid industrialization and technological advancement. A rise in manufactured goods led to increased commercialization. To meet the demands of a new consumer economy, a large and inexpensive work force was needed. In Lynn, these trends had transformed the city at an unprecedented pace during the 20 years preceding 1879. Ladies' shoe manufacturing dominated the economic landscape, with more than 150 individual firms engaged in the shoe trade and many more in auxiliary operations. The nation was emerging from the long economic recession that had plagued most of the decade, but the real income for the average shoe worker in Lynn remained between 16 and 24 percent lower than it had a decade earlier. A Knights of St. Crispin strike in 1878 had failed, leaving unresolved disputes that would flare up in the years to come. Regardless of labor troubles and low pay, the factories attracted an ever-increasing number of immigrants to the city, at the time chiefly from England, Ireland, and Canada. Native-born workers from rural New England journeyed to Lynn for work as well.

When these photographs were taken, Lynn's population of 38,000 was centered in the neighborhoods close to downtown, such as the Brickyard and the Highlands. Pine Hill, Wyoma, and Tower Hill were still sparsely settled areas; High Rock, Lynn Woods, and most of the waterfront were all in private hands. At home, Lynners did not yet have telephone service, although its use was becoming widespread among businesses. Gaslights and candles provided illumination; wood and coal stoves were used for heating and cooking. Railways and streetcars gave relatively cheap transport for freight and passengers throughout the city and its environs. The community supported 1 high school, 7 grammar schools, and 55 primary schools. The Free Public Library rented a room in city hall, and the founding of the Lynn Hospital was still four years away.

In a city that had long taken pride in the relative economic quality of its citizens, industrialization brought a widening gap between the poor and the wealthy. A few well-paying, skilled positions still existed in the shoe factories, but the average worker barely took home sustenance wages. At the same time, the most prosperous of factory owners were amassing the largest fortunes the city would ever see and had begun to build estates in the Diamond District. Ironically, the products of the busy commercial world depicted in the Fraser collection were beyond the means of many of Lynn's citizens.

Ezra D. Fraser (1854–1938) was born and spent most of his life in North Lake, Prince Edward Island, Canada, working as a salesman, farmer, and storekeeper. For a brief and somewhat mysterious period, he was employed as a photographer in the Lynn and Boston area.

One

LYNN IN 1879

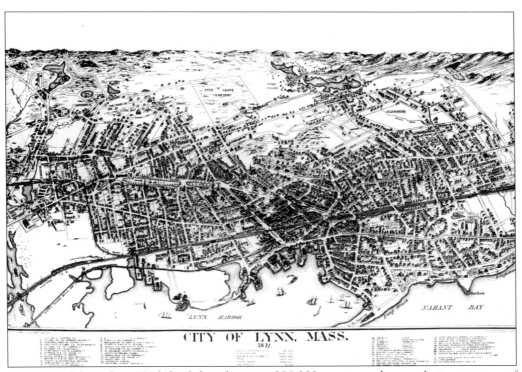

As Lynn celebrated its 250th birthday, the city of 38,000 represented a population increase of 25 percent in a mere 10 years. Women's shoe manufacturing was the major industry, and workers—both native-born and immigrant—attracted to the numerous shoe factories accounted for the rapid growth.

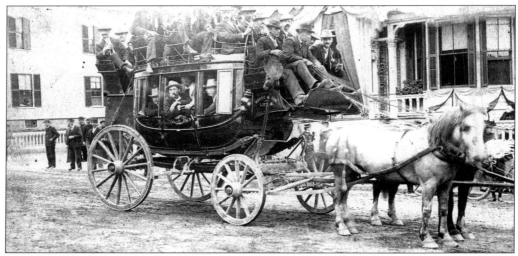

The official celebration day of Lynn's 250th birthday was chosen as June 17, 1879, although festivities occurred throughout the year. The highlight of the day was a parade featuring 3,000 Lynn schoolchildren, all 12 companies of the Eighth Regiment in the Massachusetts Volunteer Militia, and representatives of various Lynn industries. Here, a William Moore and Son express wagon is loaded with employees and assorted hangers-on.

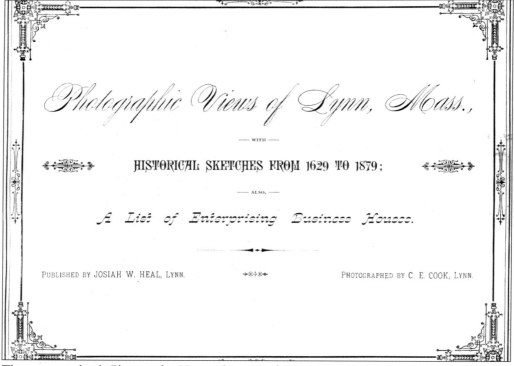

Photographic Views of Lynn, Mass.,

— WITH —

HISTORICAL SKETCHES FROM 1629 TO 1879;

— ALSO, —

A List of Enterprising Business Houses.

PUBLISHED BY JOSIAH W. HEAL, LYNN. ➤✳✦✳◄ PHOTOGRAPHED BY C. E. COOK, LYNN.

The souvenir book *Photographic Views of Lynn with Historical Sketches from 1629 to 1879* was published in 1879 to coincide with Lynn's anniversary celebration. *A List of Enterprising Business Houses* also contained a number of the images that are now part of the Lynn Museum's Fraser collection. These photographs were credited to Charles E. Cook.

The book actually contained little history but much advertising. Many of the advertisers not surprisingly were among the "enterprising business houses" whose photographs were included.

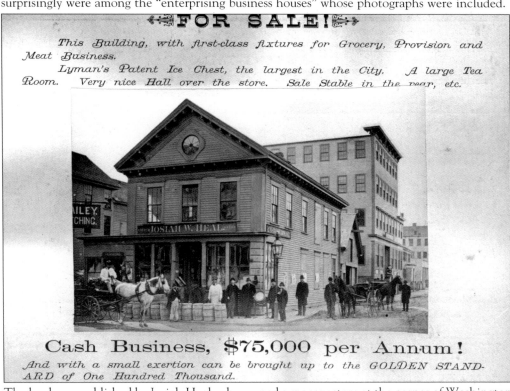

The book was published by Josiah Heal, who owned a grocery store at the corner of Washington and Oxford Streets. The store's fleet of delivery wagons and much of its inventory have been put on display in order to give the impression of a thriving business. In the book, Heal writes that he was willing to sell "at a bargain, for I am going west."

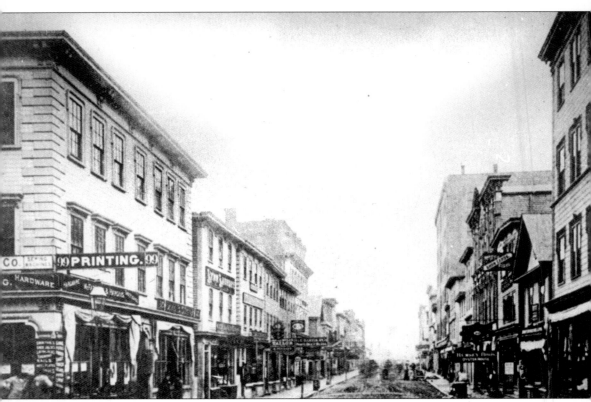

Progress and prosperity were the twin themes of Lynn's 250th anniversary year, and suitably bustling business scenes, such as this view of Munroe Street from Washington, are the main focus of the Fraser collection.

Two
MARKET STREET

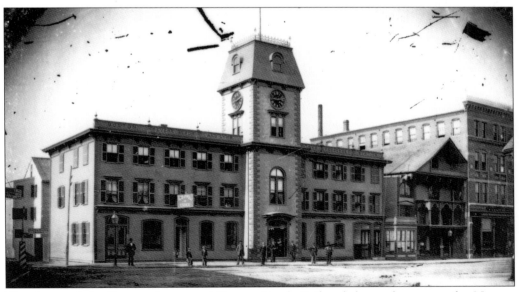

The depot of the Boston, Lynn, and Revere Beach Railroad, better known as the Narrow Gauge, stood at the foot of Market Street. The Hotel Essex shared the building, which was modified several times over the years and demolished in the 1940s.

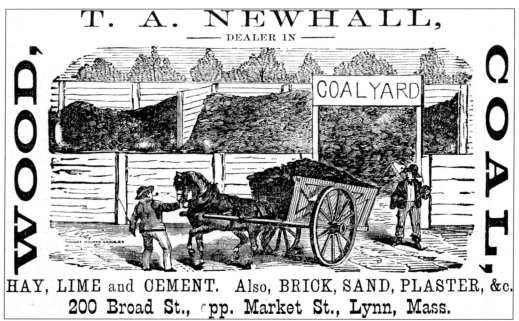

T. A. NEWHALL,
— DEALER IN —

WOOD, **COAL,**

COAL YARD

HAY, LIME and CEMENT. Also, BRICK, SAND, PLASTER, &c.
200 Broad St., opp. Market St., Lynn, Mass.

The view below of the Narrow Gauge depot shows three of the 150 shoe manufacturers operating in Lynn in 1879. The building on the far left is T.A. Newhall's coal yard, advertised in the 1879 city directory above, and behind it is Marshall's Wharf and several lumber yards.

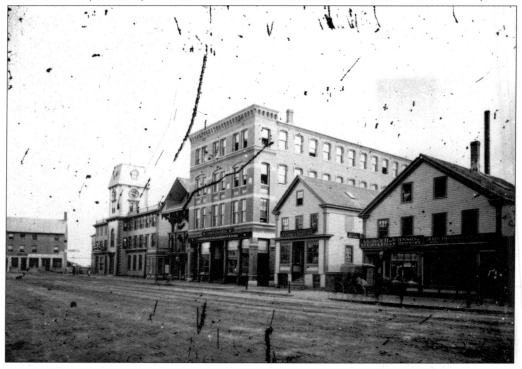

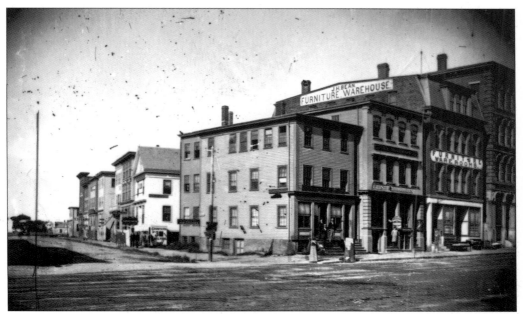

Market Street became the commercial focus of Lynn as early as the 1830s. Among the businesses visible in this view are J.H. Brear's Furniture Showroom, Brown and Oliver shoe manufacturers, and Stowell and Rhodes morocco and sheep leather manufacturers. Around the corner on State Street are J. Crowley, a cabinetmaker, and H.W. Cottle, a shoe manufacturer.

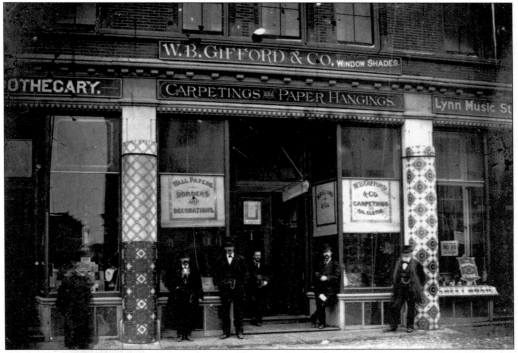

Donned in neat attire, the owners and senior staff of W.B. Gifford and Company assemble in front of the store, which was located in the Oddfellow's Building.

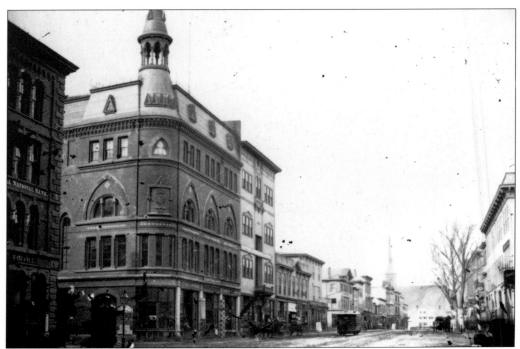

The Oddfellow's Building, constructed in 1872 and razed in 1964, stood at the corner of Market and Summer Streets at the time when Summer ran entirely through to Market, nearly opposite Andrew Street. In addition to serving as a meeting room for the eponymous fraternal organization, the building provided retail space. In 1879, the first floor was also home to C.E. Davis's apothecary, M.A. Davidson's Music Academy, and J. Bodwell's shoe store.

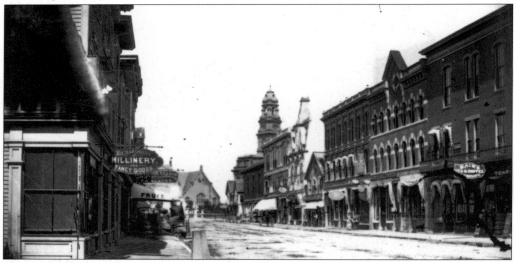

An excellent idea of the level of business activity is provided in this view of Market Street taken from Liberty. On the left side are Richardson's Millinery and Fancy Goods, an unidentified fruit dealer, and A.A. Salter's New York Branch Clothing Store; on the opposite side stands Bain's Tea and Coffee Company. In the center, the First Methodist Episcopal Church and the old city hall can be seen.

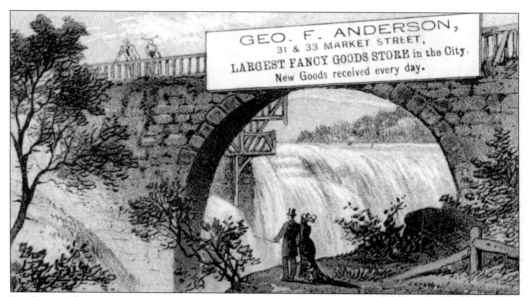

Trade cards became a popular means of advertising during the 1870s when the chromolithograph process made high-quality color printing relatively inexpensive. Cards did not always reflect the products or location of the business that distributed them, as evidenced by this plainly out-of-town view used to advertise George Anderson's Market Street establishment.

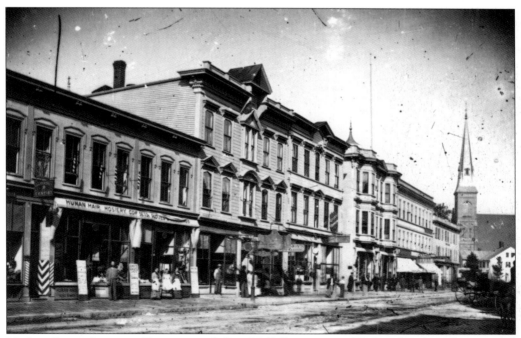

Market Street, between Tremont and City Hall Square, was filled with relatively new and commodious business blocks. Anderson's Store, advertised in the above card, appears in the foreground. The elaborate hairstyles of the period ensured that human hair was a staple in fancy goods establishments.

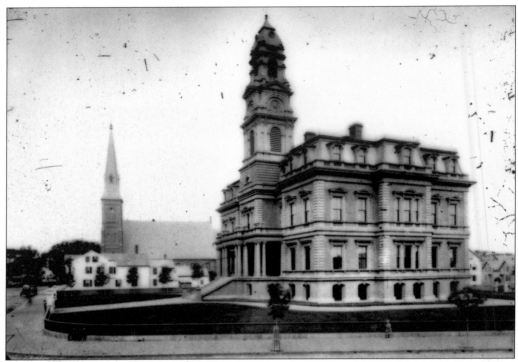

The focal point of Market Street has long been city hall. The 1867 structure was designed by noted Boston architect Gridley Bryant and was built for $311,000, a cost overrun of about 200 percent—the subject of much negative newspaper comment at the time. It stood at the same site as the present Memorial City Hall.

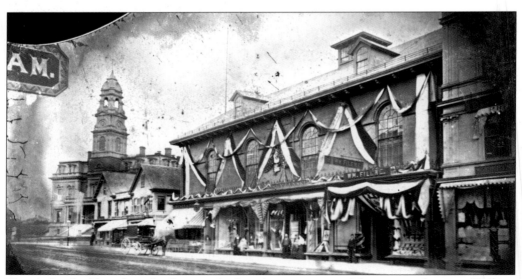

The modest building draped in bunting for Lynn's anniversary celebration was home to William Filene's furnishing goods store. Filene already owned several stores in Boston and Salem, and the chain eventually became one of the largest and most prestigious in the state.

Civil War veteran Joseph E. Hodgkins operated his "One Price Cash Boot and Shoe Store" at 22 Market Street into the early 20th century.

J. E. HODGKINS'
··· ONE PRICE ···
CASH BOOT AND SHOE STORE.
22 MARKET ST., LYNN, MASS.

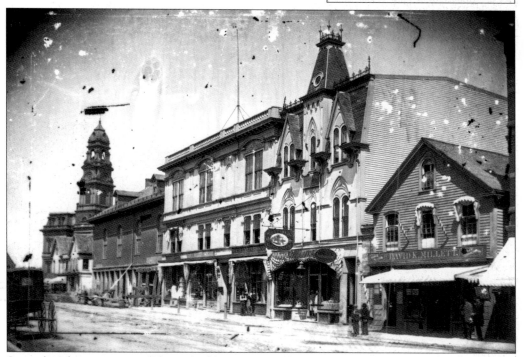

Several 18th-century wood-frame buildings were still standing in the busiest sections of Market Street in 1879, wedged in between elaborate second-empire structures like city hall (far left) and Templars Hall (second from right). The 1847 Exchange Hall, two buildings to the left, was having its ground floor remodeled to accommodate still more retail businesses when this photograph was taken.

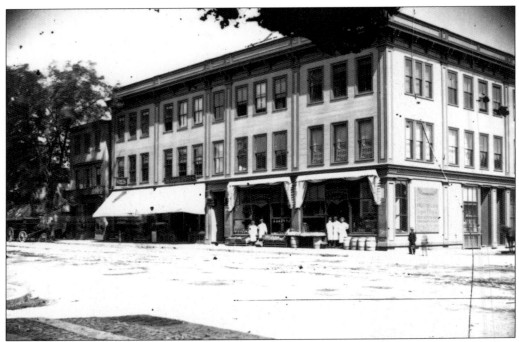

Although sidewalks and street crossings were cobbled by 1879, most of the streets themselves were not, as seen here at the corner of Market and Andrew Streets. Paving of the main streets of the city began in earnest in the mid-1880s. The substantial wood-frame building is Buffum's Block. Among the businesses renting space were Fairbanks and Sons grocers, Mahon and Sons shoe store, the Centennial Billiard Hall, and the Lynn Free Press.

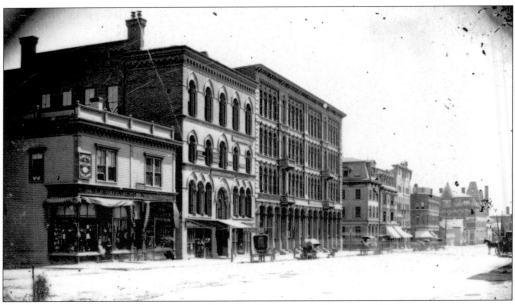

On the opposite corner of Andrew and Market Streets, looking toward Broad, a small two-story building housed Mrs. Baker's millinery shop and tailors Dowling and Ratican.

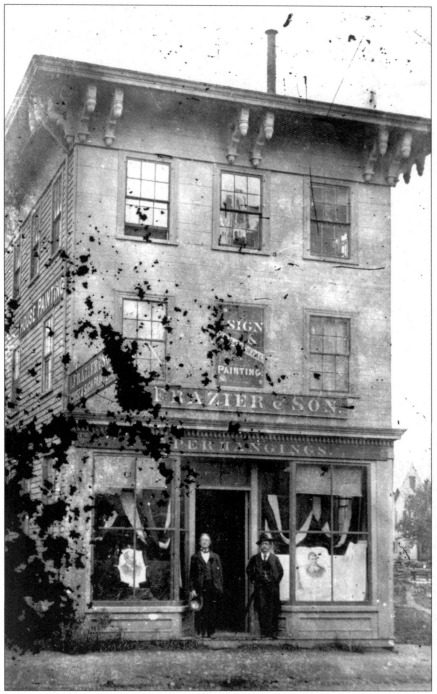

Around the corner on Andrew Street, Frazier's and Sons sign and ornamental painters was also draped in bunting. According to its advertisement, "Particular attention [was] given to Enameling Drawing-Rooms, Halls, etc. and the work warranted to retain its brilliancy. Orders attended to with promptness."

Historian James R. Newhall once referred to Lynn as "a newspaper afflicted town." In 1879, Lynn boasted five weekly and three daily newspapers. The offices of two of them—the *Lynn Transcript* and the *Lynn Reporter*—stood opposite each other at the corner of Market and Munroe Streets.

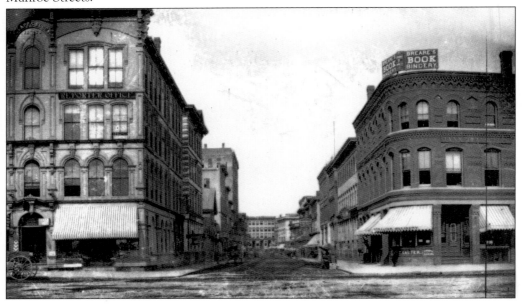

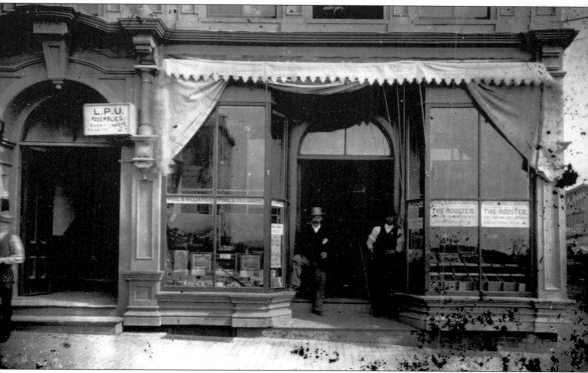

Beneath the *Reporter* office in the 1870 Clapp's Block was an unidentified billiard room and Pleasant Hall, a function room rented out to various organizations. In this photograph, the Laster's Protective Union has posted notice of its weekly assemblies; on page 22, the Knights of St. Crispin appeared. Both were shoe workers' unions.

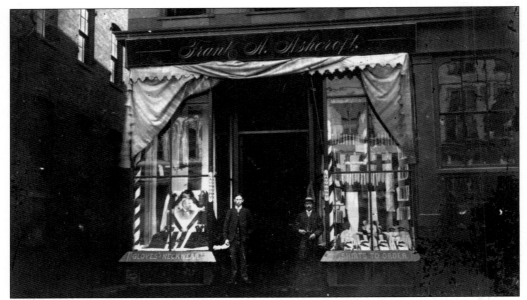

Around the corner at 21 Munroe Street, Frank Ashcroft's gent's furnishing offered "gloves, neckwear, and shirts to order." The date of this photograph is established as 1881 by the mourning picture of President Garfield featured in the window. Garfield was assassinated after only a few months in office.

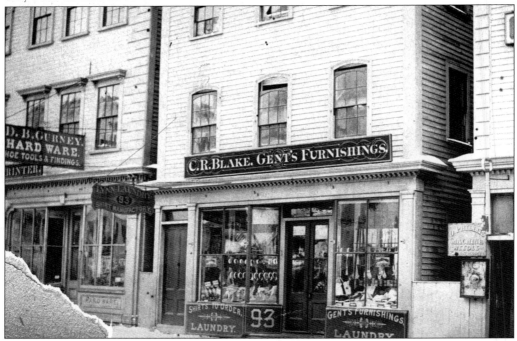

Just a block or two away at 93 Munroe Street, C.R. Blake offered virtually identical services as Ashcroft, including laundry. The largest laundries in the city had agents among various businesses, making drop-off and pickup convenient for workers who depended on public transportation.

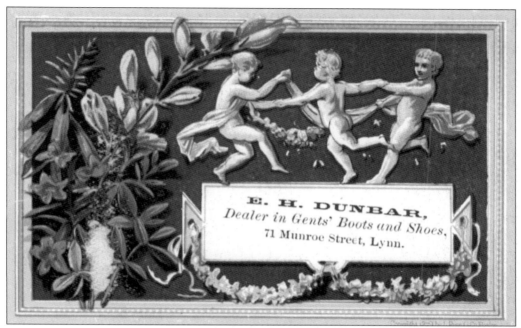

Munroe Street's retail establishments were geared toward male consumers. Everett Dunbar's gent's shoe store and Ellsworth's tobacconists were both a few doors down.

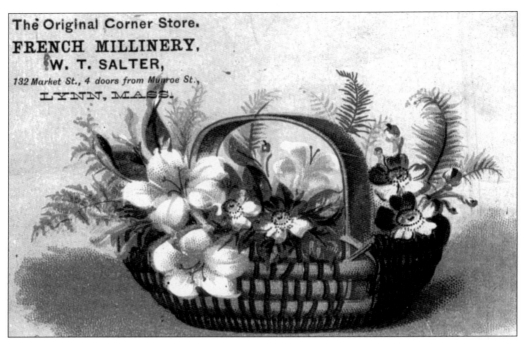

The Original Corner Store.

FRENCH MILLINERY,
W. T. SALTER,
132 Market St., 4 doors from Munroe St.,
LYNN, MASS.

W.T. Salter's millinery shop, shown below, at 132 Market Street also displayed mourning material for the late President Garfield; in this case, a newspaper declares, "Our President is Dead!" Salter's had moved in 1880 from its original location a few doors down at the corner of Market and Munroe, where it advertised itself as "the original corner store," as seen above.

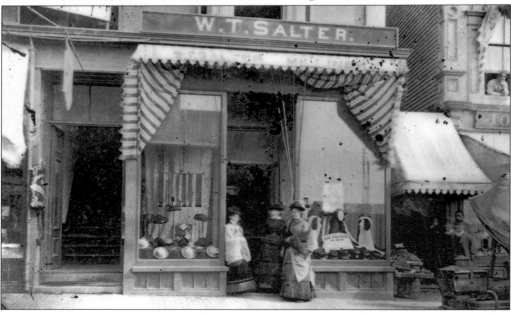

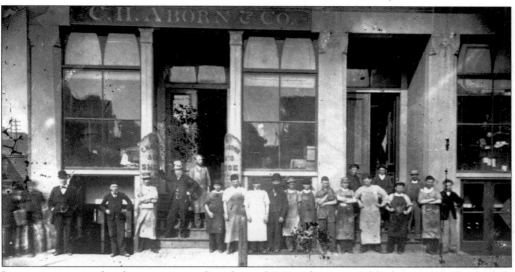

In a pattern quite familiar, owners and workers of C.H. Aborn assemble for a group photograph likely taken at the same time as the one on page 28.

P. LENNOX & CO.,

MANUFACTURERS OF AND DEALERS IN

GOAT, KID AND MOROCCO

Salesroom, 19 HIGH ST., BOSTON. No. 162 MARKET ST., LYNN, MASS.

Proprietors of LENNOX'S PATENT BEAMING MACHINE for Beaming Hides and Skins.

F. P. & A. K. DROWN, Manufacturers of and Dealers in Kid, Pebbled & Curried Goat, Brushed, Glazed & Pebbled Sheep, Rear Market St., nearly opp. Munroe St., *Lynn, Mass.*	John W. Blaney. Elbridge Blaney. **BLANEY BROS.,** Manufacturers of all kinds of Morocco, Kid, Goat, Linings, Skivers, &c. *Harrison Court, Lynn.*	**EUGENE BARRY,** Manufacturer of Kid, Goat & Morocco, Skivers & Linings of all Colors, *145 and 147 Market St.,* Lynn, Mass.
JEREMIAH DOHERTY, Manufacturer of Kid, Goat, Sheep & Morocco, *Harrison Court, Lynn.*	**JOHN T. MOULTON,** Manufacturer of KID, GOAT and MOROCCO, *Imitation French and Pebbles,* Salesroom, 161 & 163 Market Street, Factories, 11, 13 & 15 Marion Street. **Lynn.**	*HENNESSY & PURDON,* Manufacturers of KID, GOAT, and MOROCCO, Sheep Skins *20 Beach Street, Lynn.*

Twenty-five morocco manufacturers existed in Lynn at the time, several of them in the immediate vicinity of Market Street and Harrison Court. Morocco is a type of leather widely used in fine shoemaking.

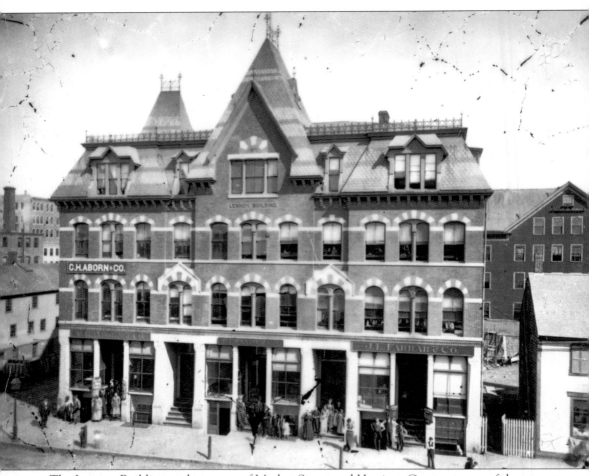

The Lennox Building at the corner of Market Street and Harrison Court was one of the newest and largest buildings in the city devoted to shoe manufacturing and was home to C.H. Aborn and Company, P. Lennox and Company, and J.E. Farrar and Company, all shoe and leather businesses. This building burned not long after this photograph was taken, and a larger Lennox Building was built on the same site, where the MBTA parking garage now stands. The presence of the numerous older, wooden buildings seen surrounding the brick Lennox Building helps account for why such a large part of this area was so quickly destroyed in the fire of 1889.

Three
UNION STREET AND
CENTRAL SQUARE

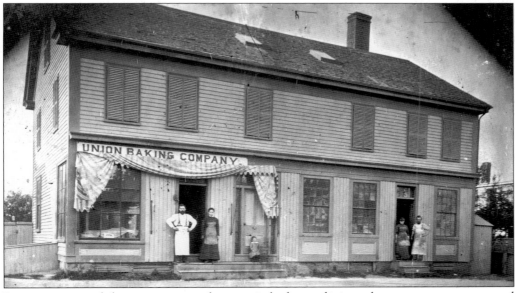

Lynn was unusual for a city its size because it had two distinct downtowns—one centered around Market Street and another around Union Street, a pattern which persisted into the mid-20th century. Frank Brintall's Union Baking Company was located at 7 Union Street near Chestnut in a building that, much altered, still stands.

This view of Union Street looks down Lincoln Street at the old St. Paul's Church, which burned in 1958. Today, Christ Church United Methodist stands at the same location.

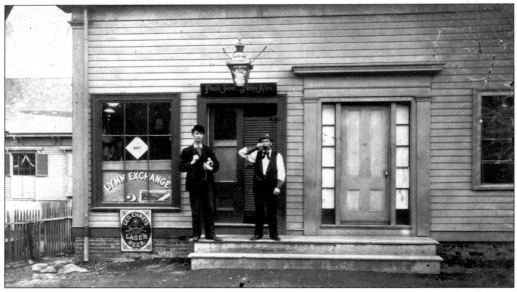

In 1879, the telephone was just coming into widespread use in Lynn. George H. Dyer's saloon at 26 Union Street doubled as the Woodend Exchange, or Lynn Exchange No. 2. Dyer most likely appears on the left, posing with an unidentified employee who is sampling the establishment's product.

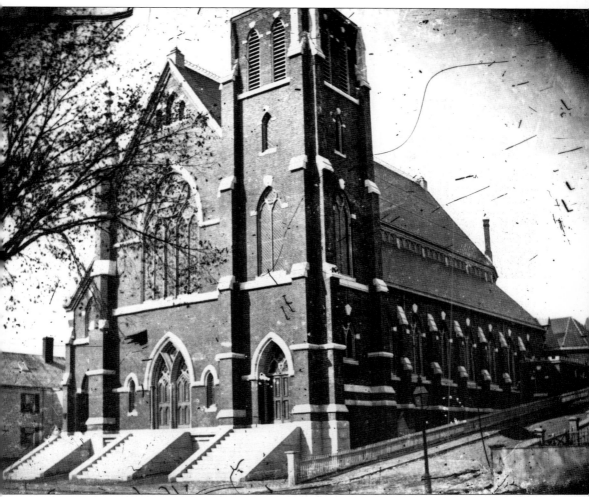

The imposing structure of St. Joseph's Catholic Church has been a landmark on Union Street since its dedication in 1876.

TRY THE

NATIONAL ✦ FOOD,

—FOR—

Horses, Cattle, Sheep, Swine and Poultry.

Manufactured by the

National Food Company,

No. 3 PINKHAM STREET, LYNN, MASS.

Eugene Bessom's National Food Company, below, at 34 Union was one of 128 grocery stores listed in the 1880 Lynn city directory. Presumably, more efficient delivery vehicles than the bicycle propped at the door were available for the advertised coal delivery. The identity of the "Lottie" shown in the trade card on the left has been lost.

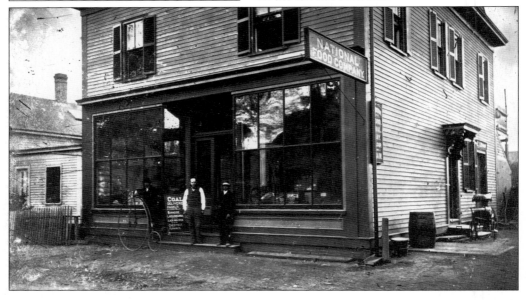

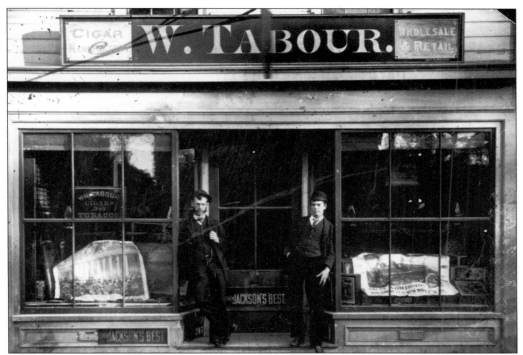

William Tabour's at 68 Union Street was a cigar factory, selling to both the wholesale and retail trades.

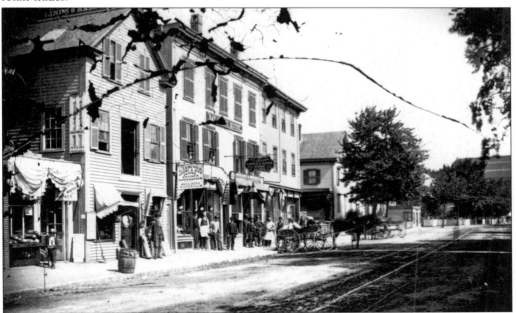

Charles Jepson was the proprietor of both the Bay State House and a dining saloon at 103 Union Street. The rear of St. Joseph's can be seen at the right; the small wooden building on the left is Ora Seavey's fish market. The Bay State House appears to have been a residential hotel catering to long-term guests.

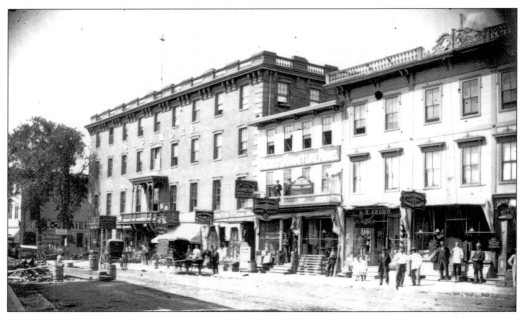

Another hotel, the Sagamore House, was only a block away at 133 Union Street. Next door at French's Furniture Rooms, two workers have hauled a headboard onto a balcony to demonstrate the company's wares.

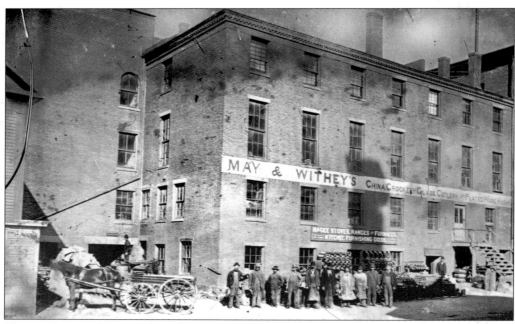

The employees of May and Withey home furnishings line up at the delivery entrance behind 137 and 141 Union Street.

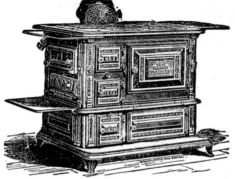
Sometime during 1879 Mr. May bought controlling interest in the business that was then known as L.A. May and Company. For many years it was one of the largest home furnishing stores in the city.

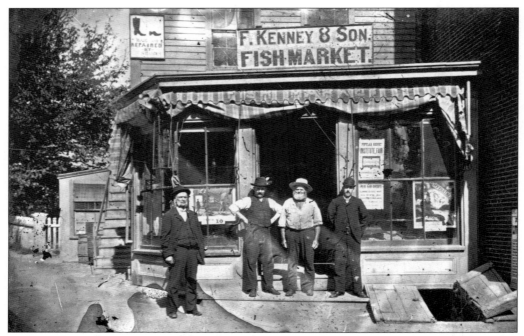

For stereotypically picturesque old Yankees, this group in front of Francis Kenney's fish market at Union Square can hardly be improved upon. The posters in the windows advertise, among other things, "Institute Fair, Grand Concerts Every Night," and "Falconner's Great Emotional Drama *Eileen Oge*"at the Music Hall.

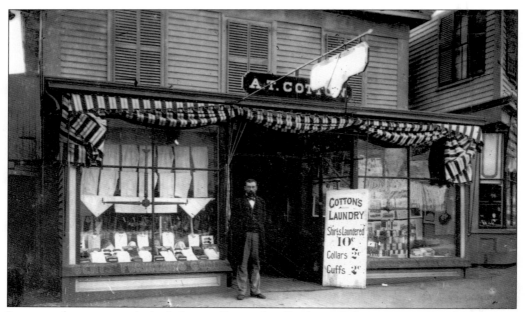

Lynn gentlemen never lacked clean collars and cuffs. Around the corner on Pearl Street was A.T. Cotton's, yet another gent's furnishing store and laundry agent. Five more were located on Union Street proper.

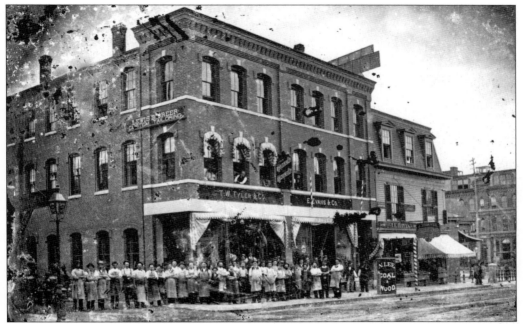

Once again the entire work force was on hand for a photograph. T.W. Tyler and Company was a wholesale and retail dealer in manufacturer's supplies such as machine oils, engine supplies, and rubbers hose. The building was situated at 160 Union Street, just opposite Almont Street.

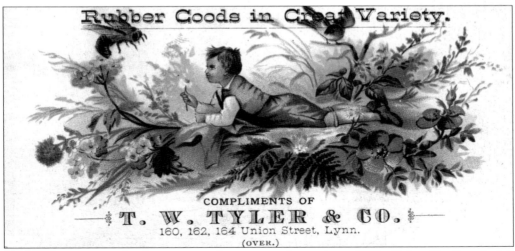

Without any particular bearing on the company's product, T.W. Tyler distributed this whimsical trade card around the same time the above photograph was taken.

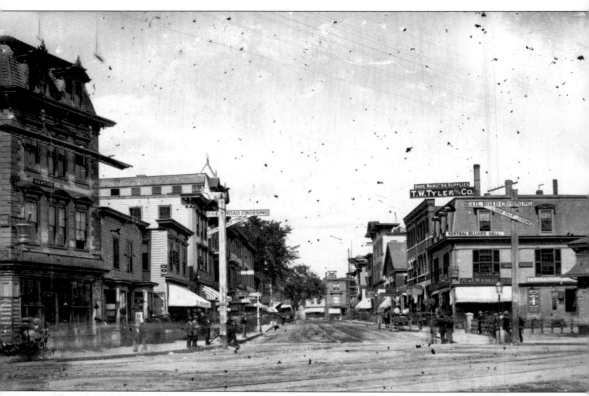

This view is looking down Union Street from Central Square, which was created when the first railroad was built through Lynn in 1838. Easy rail access soon made it the commercial and industrial hub of the city.

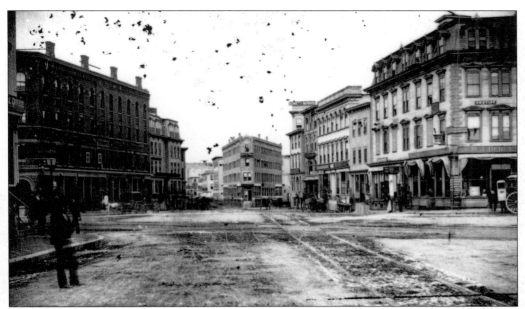

Central Square is shown here again, from the opposite direction. The small flatiron building in the center is Kimball Brothers shoe manufacturers. The ghostlike quality of the man in the left foreground may be attributed to his moving during the lengthy exposure time required by late-19th-century photography.

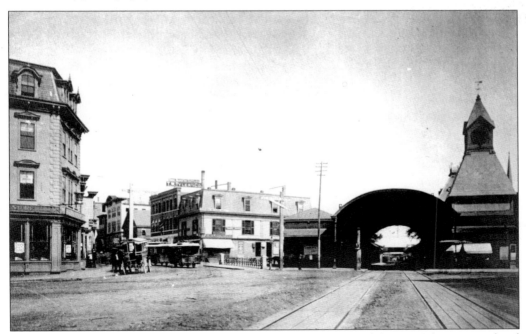

The depot of the Eastern Railroad was the *raison d'être* of Central Square. These street-level tracks were not only an inconvenience to pedestrians and horse wagons but also they were often a deadly menace. After numerous fatalities over the years, the tracks were finally elevated in 1913.

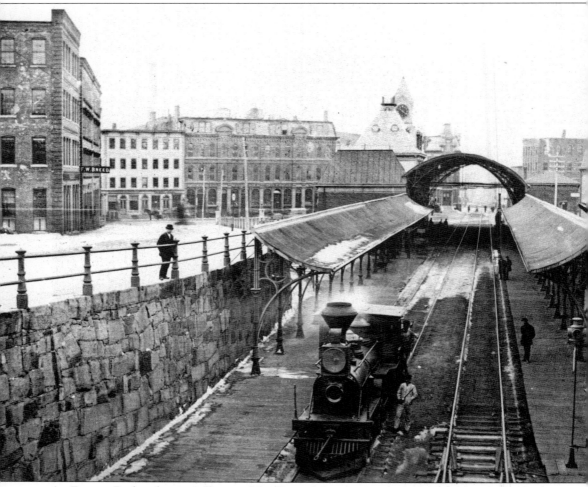

An Eastern Railroad train pulls out of the Central Station, just before the Silsbee Street Bridge. The Francis W. Breed shoe manufacturer on Mount Vernon Street is visible on the left.

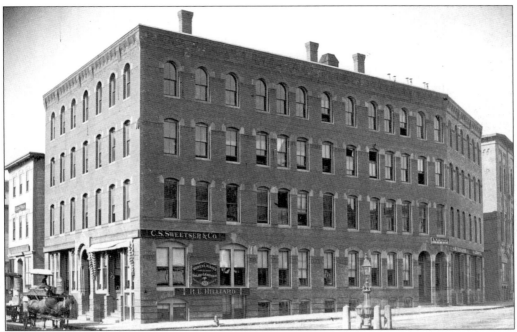

One of the major streets feeding into Central Square was Central Avenue. The Sweetser Shoe Company was located at the junction of Central Avenue, Washington Street, and Oxford Street. The street lamp in the foreground, although of attractive construction, seems inconveniently placed in the center of a busy street.

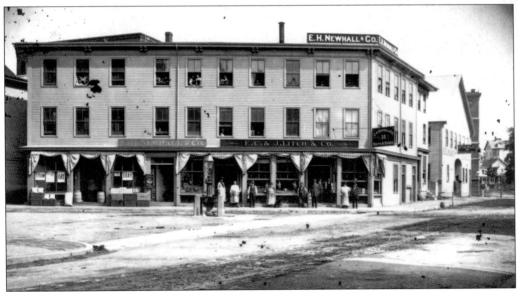

The tracks of the Bay State Street Railway Company are visible on Central Avenue. The view here depicts the opposite corner from the above photograph.

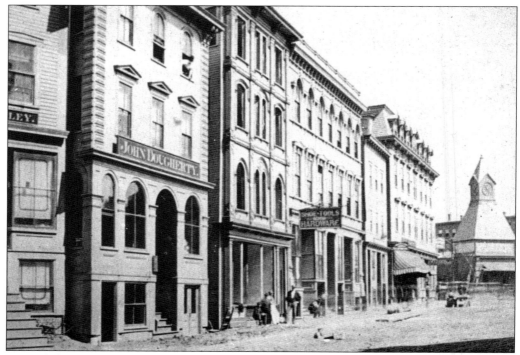

Toward the railroad depot on Central Avenue (seen here from Blake Street) were more shoe factories. Despite the appearance given by the ornamental facades, most of these were wood-frame buildings.

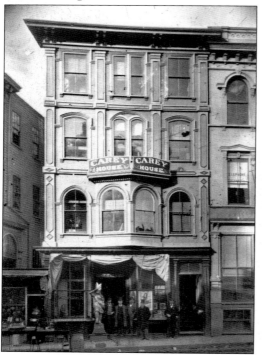

The center building in the photograph above is the Carey House Saloon, operated by John Carey. Saloon-keeping was apparently a family trade; his brother Bernard owned two similar establishments on Blossom and Harbor Streets. The painted Indian in front belonged to John H. Hilton, a cigar maker.

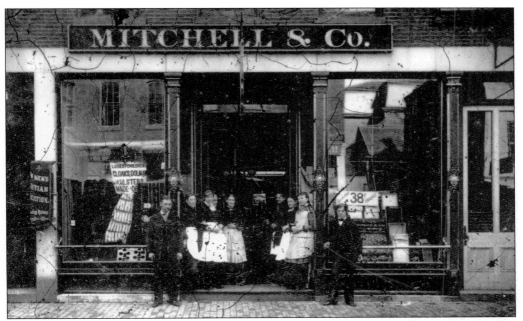

Mitchell and Sons at 67 and 69 Oxford Street was a family dry goods establishment, judging from the mixed-gender staff and the window advertisements for ladies' and children's cloaks and 38-cent undervests.

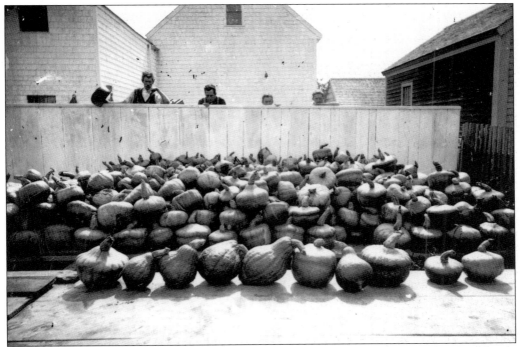

At the corner of Washington and Oxford Streets was Josiah Heal's grocery store (shown previously on page 11). In the yard behind, Heal and his employees show off a bumper crop of squash.

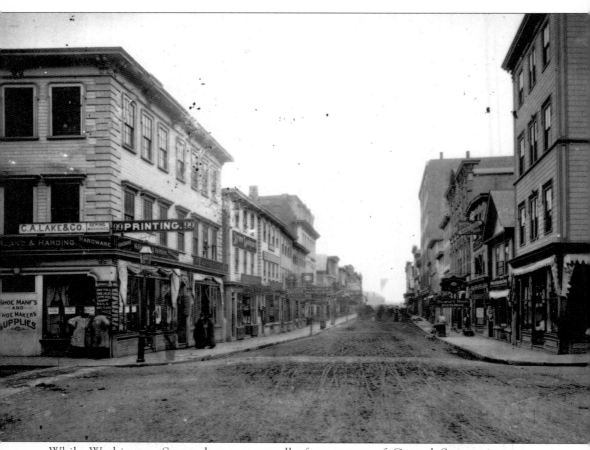

While Washington Street does not actually form a part of Central Square, its numerous businesses have always added to the general activity of the scene. At the corner of Munroe Street were, among others, C.A. Lake sewing machine repair, McFarland and Harding hardware, the Lynn Laundry, the Temperance Coffee House, the Rumsey Brothers Oyster House, and the St. Crispin Dining Rooms.

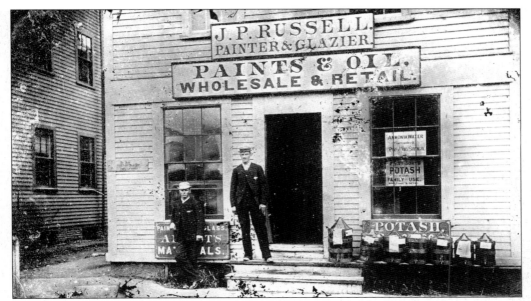

At 210 Union Street stood the John P. Russell paints and oils. The potash prominently advertised for "family use" was primarily used for garden fertilizer or soap-making.

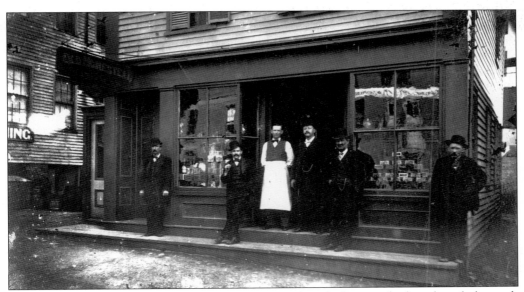

The small alley to the left is Railroad Avenue, now Arcade Street, which is directly beneath the commuter rail bridge at Central Square. A sign identifies this establishment as the "Old Homestead Ladies Saloon." The all-male staff may or may not have been an attraction for the intended clientele. To the left is Francis Thing and Company hay and grain dealers.

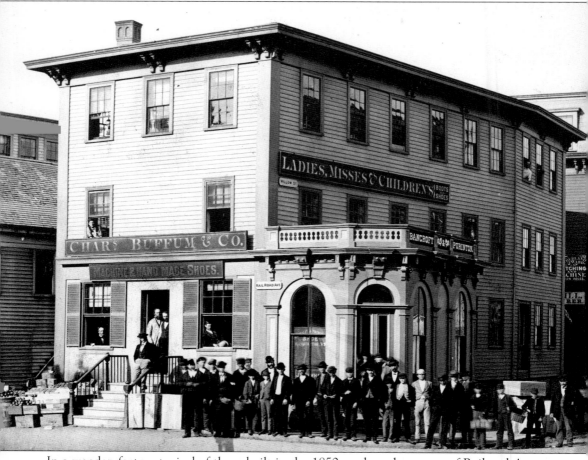

In a wooden factory typical of those built in the 1850s and on the corner of Railroad Avenue and Willow Street stood Charles Buffum and Company, one of the few manufacturers in Lynn still offering handmade shoes.

Four
THE HIGHLANDS
AND VICINITY

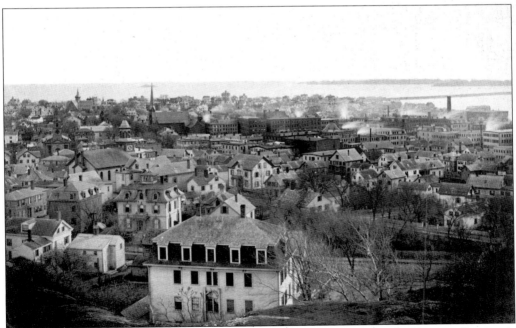

One of the few residential neighborhoods documented extensively in the Fraser collection is the Highlands. Bounded by Western Avenue and Essex, Washington, and Chestnut Streets, this area saw increased settlement during the mid-19th century by both workers and factory owners attracted by its pleasant views and easy access to downtown.

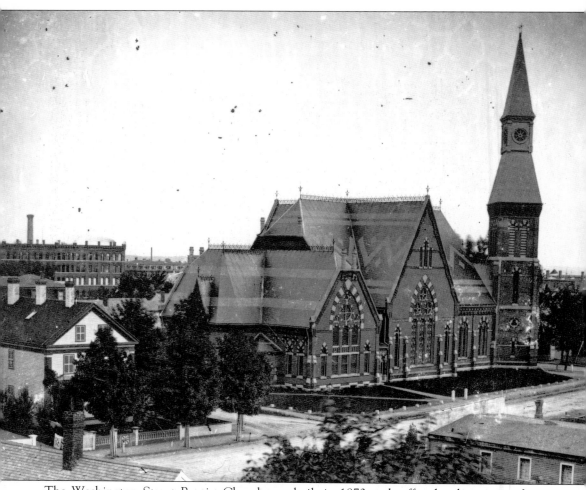

The Washington Street Baptist Church was built in 1873 and suffered a devastating fire in 1905. Rebuilt the following year, it still conforms to much of its original design.

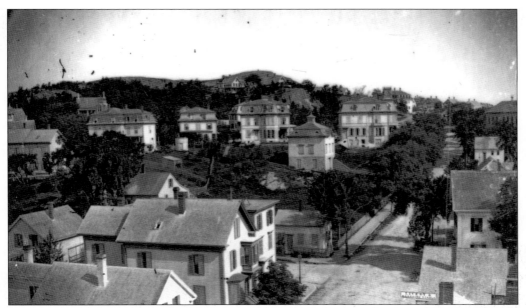

This view of Liberty Street from Washington Street looks into the lower Highlands. J.W. Young's livery stable in the right foreground stood at the spot where the old post office building now stands. The old high school building is at the top right.

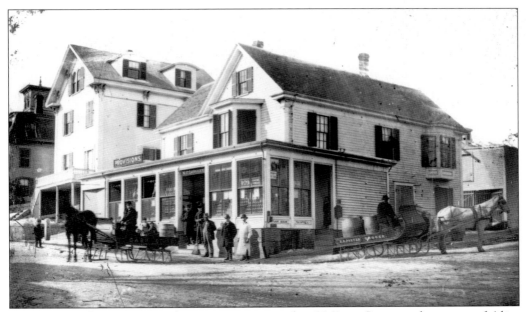

Miner P. Longley's grocery and provision store stood at 91 Essex Street at the corner of Alice Street, now Alice Avenue. The sled on the right delivers goods from H.D. Porter, another grocer at 69 through 71 Union Street.

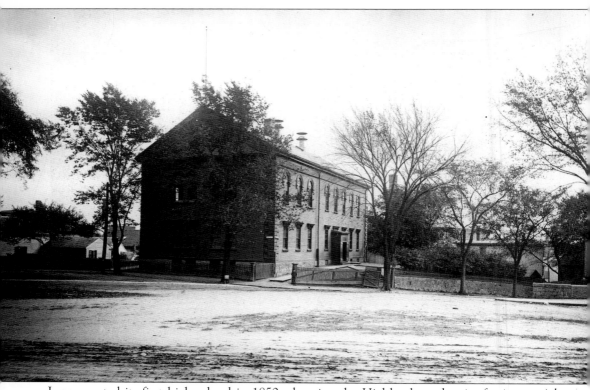

Lynn erected its first high school in 1850, choosing the Highlands as the site for its central location. While hailed as "a beautiful and commodious schoolhouse" by Mayor George Hood at the time of its construction, by 1880—in a refrain that will sound familiar to modern ears—it was bemoaned that "the old building was insufficient to accommodate all," and several classes were moved to the Cobbet School building.

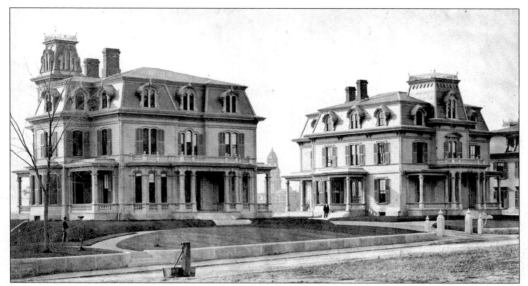

Highland Square, later the site of the Lynn English High School, was one of the most fashionable addresses in the city during the 1880s. The home on the left belonged to Lyman B. Frazier, and that on the right to F.S. Newhall, both shoe manufacturers. City hall can be seen in the background.

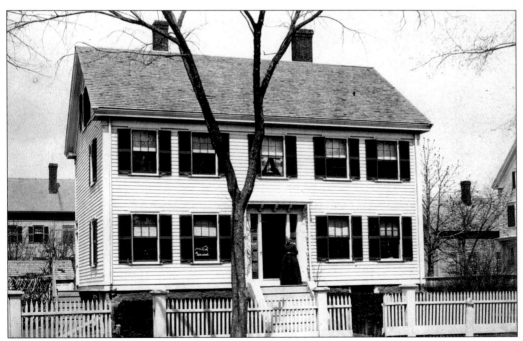

The Burrill Homestead, as it was called, stood on Hanover Street near Washington Street. The Burrills were among the earliest European families to settle in Lynn.

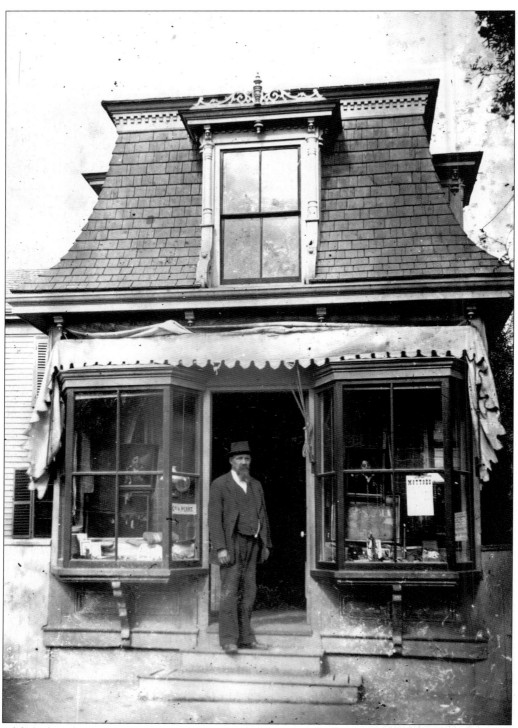

Although only Charles Perry stands before his picture-framing shop at 127½ Essex Street, near Chestnut Street, his wife also ran a fancy goods business at the same address.

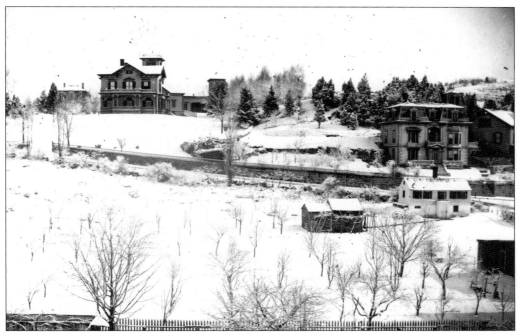

These two views—winter and summer—show the home of morocco manufacturer Augustus B. Martin on High Rock Avenue, now Lawton Avenue. Considered one of the finest homes ever built in Lynn, it was later headquarters for Post 501 of the Veterans of Foreign Wars for many years.

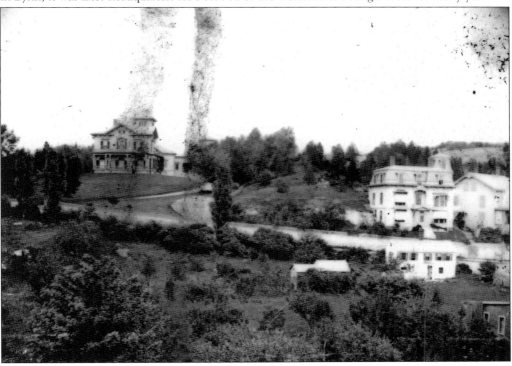

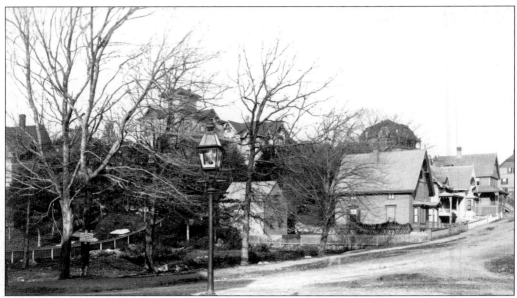

Today, the corner of Hamilton and Lawton Avenues is filled with the modest single-family homes more typical of the neighborhood than the Martin estate.

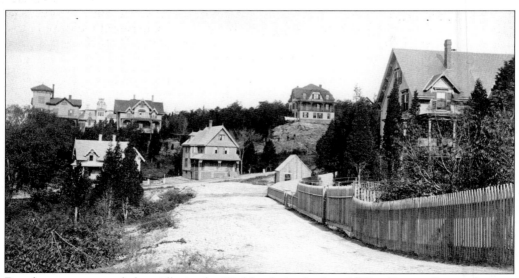

Development proceeded rapidly in the Highlands in the late 1870s. Grover Street, then an unnamed alley, was one of several that had recently been subdivided into house lots. The view here looks toward Hamilton Avenue. The house at the foot of Grover still stands. (Photograph by John Batchelder.)

54

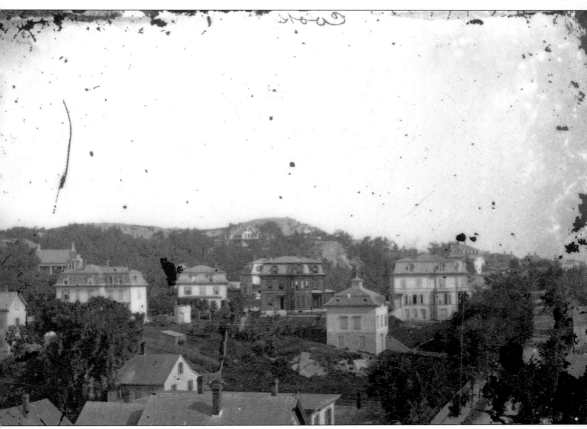

High Rock itself looms above the Highlands looking oddly barren without its tower. The original wooden structure had been sacrificed to an enthusiastically patriotic bonfire at the close of the Civil War, and a new one was not raised until 1905. The photographer has scratched his name—Cook—at the top of this negative.

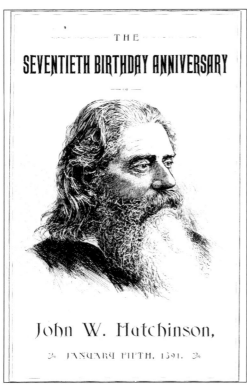

THE

SEVENTIETH BIRTHDAY ANNIVERSARY

— of —

John W. Hutchinson,

JANUARY FIFTH, 1391.

The Hutchinson Family Singers, a nationally known troupe advocating abolitionism, women's rights, and other reform movements of the day, settled at High Rock in the early 1840s. John Hutchinson, shown here, remained in Lynn until his death and eventually donated the park to the city.

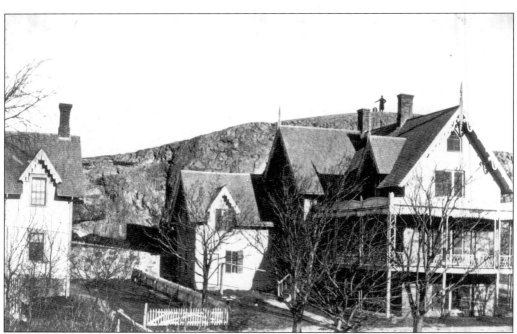

Stone Cottage, on the right, was the first residence the Hutchinsons built at High Rock; the structure still stands. Part of Daisy Cottage, a later addition now long gone, is visible on the left.

56

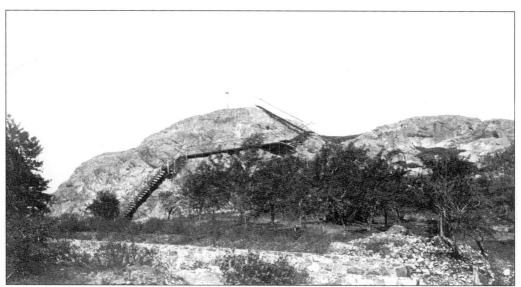

A simple rise of wooden steps led to the summit of High Rock. Despite being private property, the area was a popular destination for picnicking and an almost irresistible viewing spot.

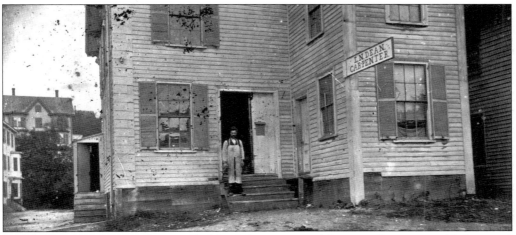

Leander Dean's carpentry shop on Highland Avenue, near Mountain Street, most likely served as his residence as well.

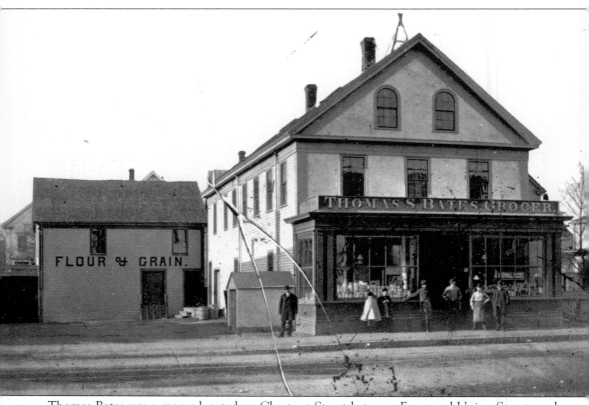

Thomas Bates was a grocer located on Chestnut Street between Essex and Union Streets and nearly opposite Mason Street. Though much altered, the building continues to house both retail stores and residents today.

Five
BROAD STREET AND THE DIAMOND DISTRICT

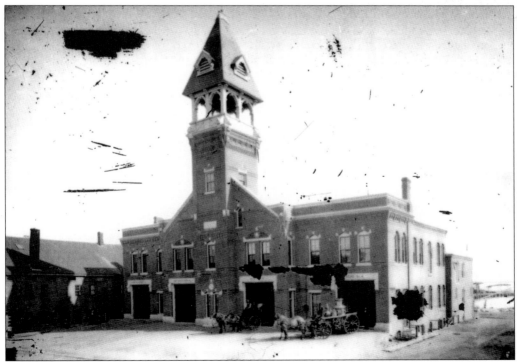

Constructed in 1878, the Broad Street fire station was described by James R. Newhall in the official anniversary volume as a "pride to the fire department and an ornament to the city."

Two businesses that would be made obsolete by the rise of the automobile—C.A. Todd's wheelwright shop and George Clapp's blacksmith shop—stood on Broad Street, just opposite Spring Street. The depot of the Narrow Gauge railroad appears in the center at Market Street; the tower of the Broad Street firehouse can be seen on the left.

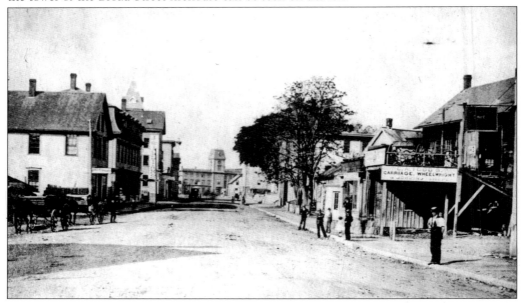

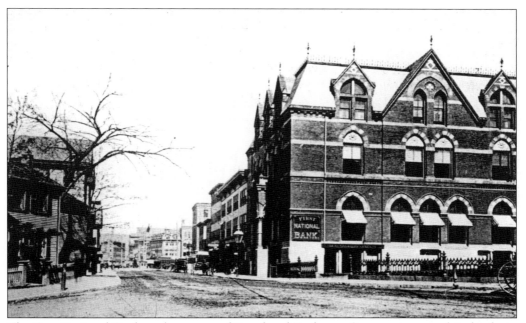

The First National Bank at the corner of Broad and Exchange Streets was one of six banks in Lynn. The building was entirely destroyed in the fire of 1889.

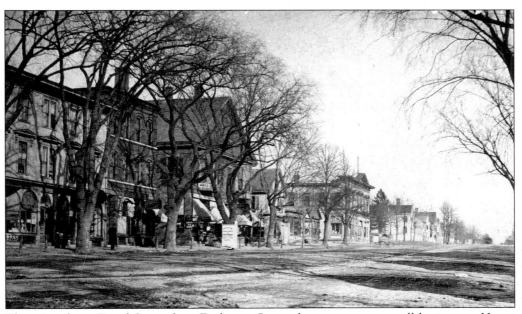

This view down Broad Street from Exchange Street shows numerous small businesses. Heavy industry was mostly confined to the western end of the street.

DREW & ANNIS,

DEALERS IN

GROCERIES

—AND—

PROVISIONS,

J. COLBY DREW.
C. W. ANNIS. } *93 Broad Street, Lynn, Mass.*

Shown here are Drew and Annis, grocers at 93 Broad Street, and Clarence Tozzer, an apothecary at 95. The sign in Tozzer's window advertises hellebore, a product used for killing lice and caterpillars on plants and, in this case, currant worms. On the far left stands the home of Nathan Breed.

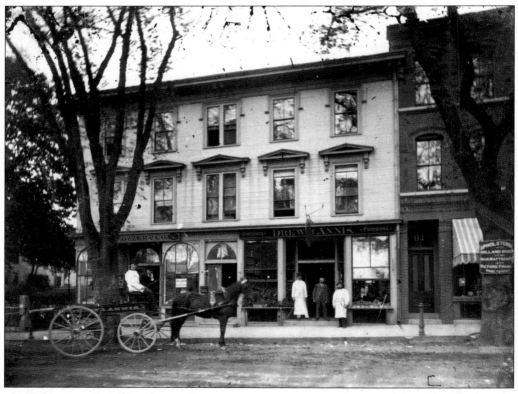

Morocco manufacturer Phillip Tapley built this factory at 114 Broad Street in 1843. It was lost entirely in the fire of 1889, and a new, larger establishment was erected in the same place. This second building was destroyed by fire as well in 2000. Tapley's elegant home on Linwood Avenue later became the first Union Hospital.

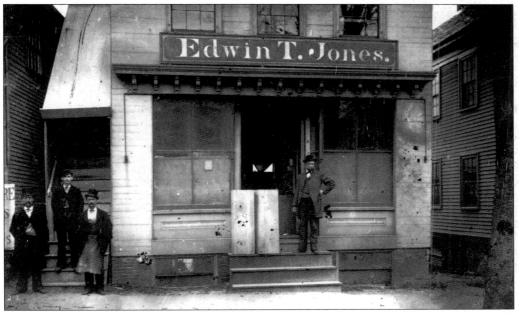

Not far from Tapley's impressive complex, Edwin T. Jones was manufacturing on an apparently much smaller scale at 94 Broad Street. Jones made ladies' shoes, and his factory resembles that of the very earliest built in Lynn. It most likely dates to the 1820s.

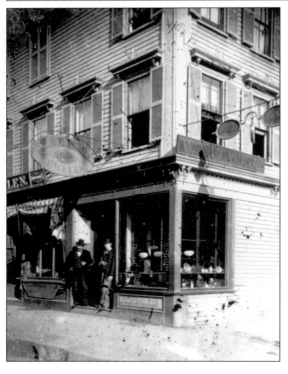

At 83 Broad Street, near the corner of Silsbee Street, stood W.A. Clark, a jeweler, who also had a branch store at 116 Union Street. As indicated by the sign on the Silsbee Street side, eyeglasses were a commodity generally handled by jewelers rather than opticians.

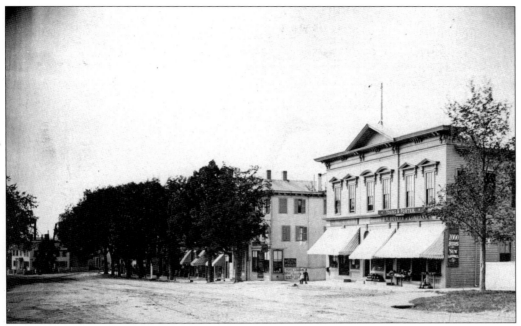

Young and Porter, grocers at 67 and 69 Broad Street, advertised the arrival of 1,000 boxes of new sardines. The business had been taken over in 1880 from Phineas Butler, who had moved to California.

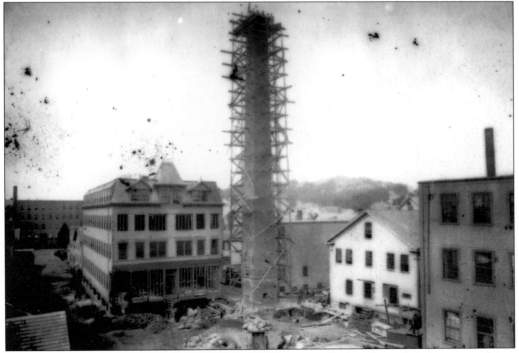

Judging from the location of High Rock in the distance, the smokestack being erected was probably on Broad or Sea Street near the wharves.

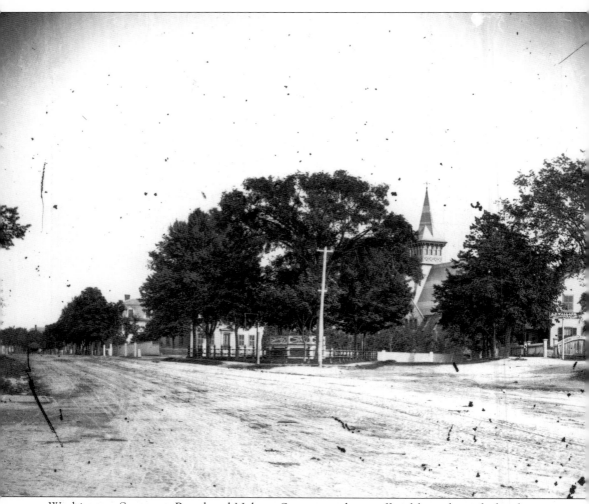

Washington Square at Broad and Nahant Street was the unofficial boundary of what became known as the "Diamond District," Lynn's most posh residential neighborhood. The name was originated by Lynners from other neighborhoods as a gentle poke at what was perceived to be pretensions to grandness. Dr. John Emerson's home and office are to the right, and the steeple of the First Universalist Church is visible to the center right.

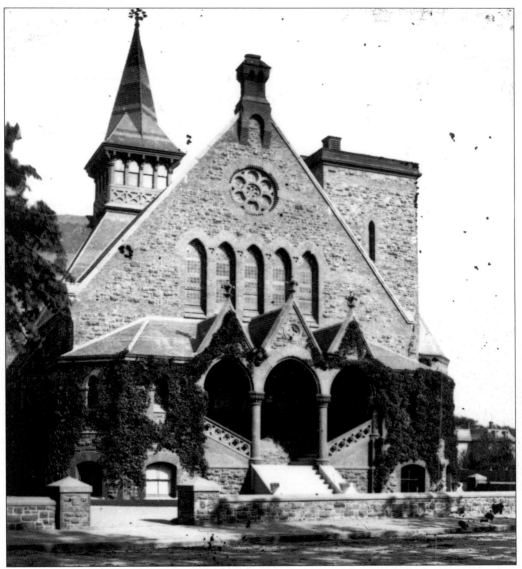

The First Universalist Church on Nahant Street, erected in 1873 and shown here before its completion, was a striking structure. The church was finished in 1886 with the addition of a bell tower on the right, but the structure succumbed to fire in 1976.

One of the earliest homes on Nahant Street was the 18th-century William Bassett house, which was torn down a few years after this picture was taken.

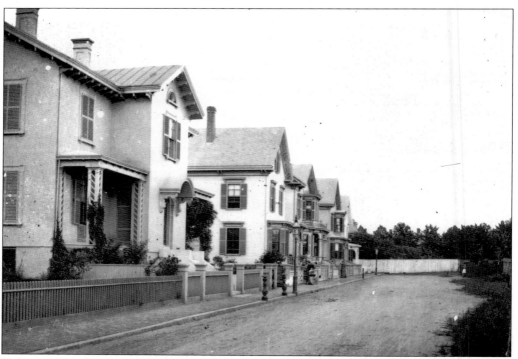

Nahant Place was laid out in the 1870s and, by 1880, was occupied on only one side with relatively modest, wood-frame homes. The opposite side consisted of back lots of the larger estates on Baltimore Street.

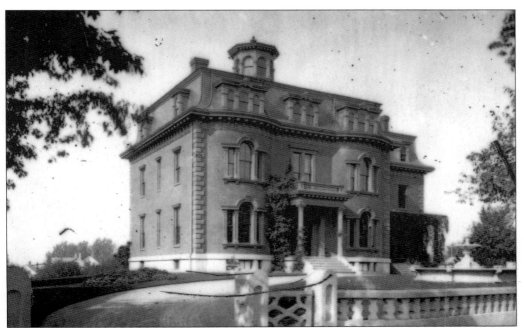

John B. Alley, a U.S. congressman, shoe manufacturer, and financier, was one of Lynn's wealthiest citizens, as shown by this grand home he built on Nahant Street. The home was later rotated to face Broad Street.

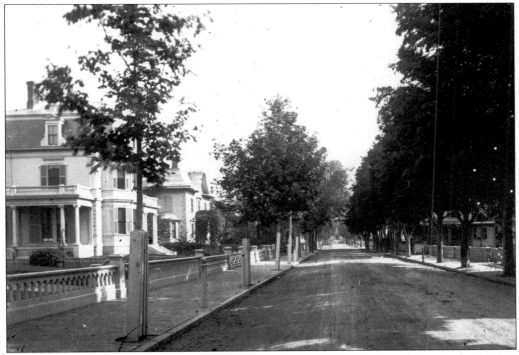

The pleasant suburban atmosphere that permeated most of the Diamond District by 1880 is evident in this view of Baltimore Street.

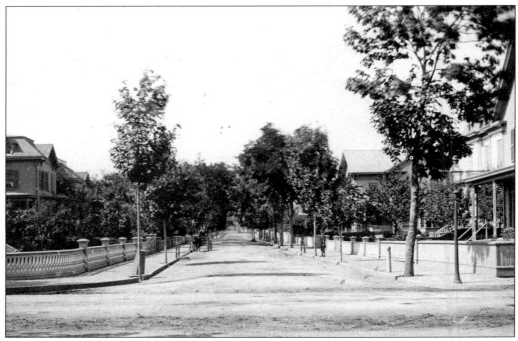

Most of the pleasant, middle-class homes on this section of Atlantic Street, north from Ocean Street, had been built in the previous 20 years.

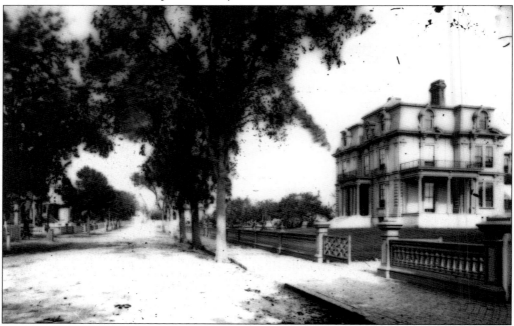

This fine home on Atlantic Street, unlike many others, did not belong to a shoe manufacturer. It was built by William Melcher, who listed his business address simply as American Express, Boston. Presumably, he did more than drive an express wagon.

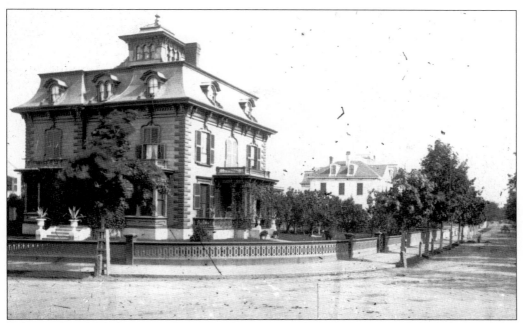

A home that did belong to a shoe manufacturer was that of Lucien Newhall at the corner of Ocean and Nahant Streets. One of the gems of the Diamond District and indeed the city, it is today on the National Register of Historic Places. Newhall, like many of his contemporaries, was involved in numerous other businesses and charitable organizations aside from his shoe factory, including Lynn Gas and Electric, Lynn Hospital, and Associated Charities.

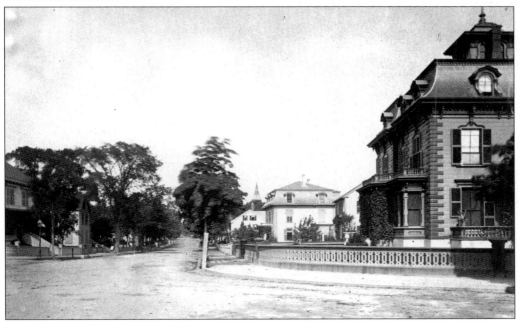

This view, looking back up Nahant Street toward Broad Street, shows the grander scale of the Newhall house in comparison to its neighbor.

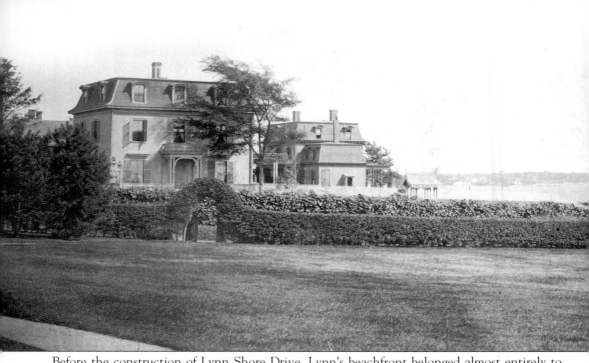

Before the construction of Lynn Shore Drive, Lynn's beachfront belonged almost entirely to the large estates off Ocean Street. In this view, from the lawn of Joseph Iasigi, an Armenian diplomat, the houses stand approximately where Deer Cove and Grosvenor Park are today.

Six

THE COMMON, MARKET SQUARE, AND WESTERN AVENUE

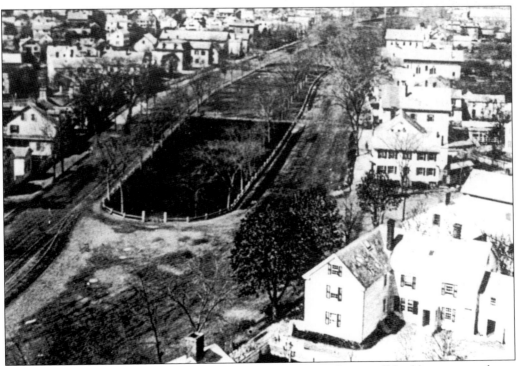

In a time when aerial photography had not been anticipated, any tall building was used as a vantage point. This early view of the common was taken from the tower of city hall.

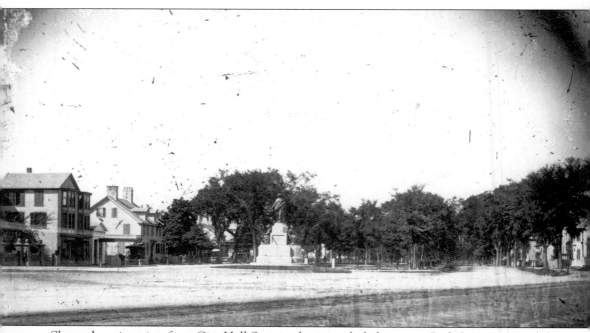

Shown here is a view from City Hall Square, then popularly known as Park Square, toward the common. On the far right, the white wood-frame house stands where the public library is today. The tracks in the foreground belong to the Boston and Lynn Horse Railroad; electric cars were still eight years into the future.

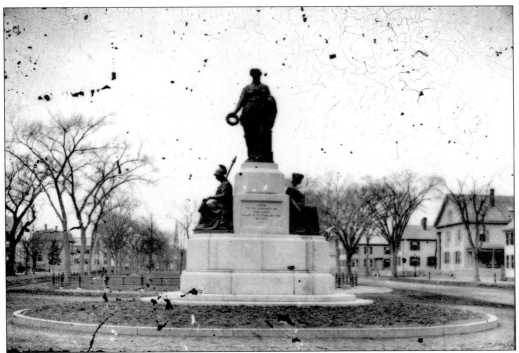

Lynn's Soldiers Monument was dedicated in 1873 in memory of the more than 3,000 Lynn men who served in the Union army during the Civil War. The three figures represent, from left to right, War, the Spirit of Lynn, and Justice.

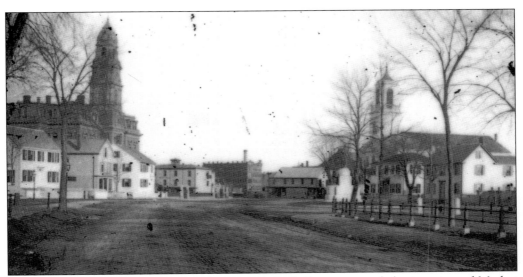

This view looks from the opposite direction at Park Square toward the junction of Market Street, Central Avenue, and Essex Street. The Methodist Episcopal church on the right was built in 1812 and included a Revere bell. It was known, for reasons unclear today, as the "Old Bowery."

75

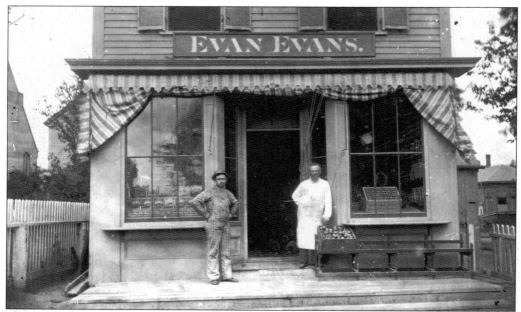

Evan Evans Jr. and Sr. pose in front of their grocery store next to the church at Park Square. The two commuted from their home in East Saugus.

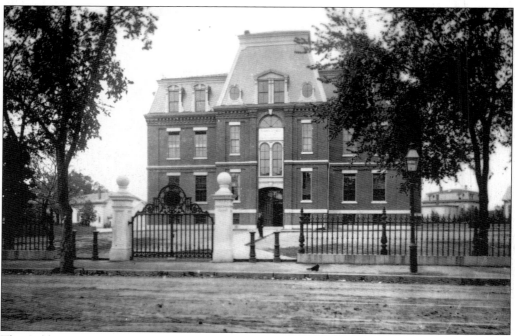

The Cobbet School on Franklin Street was erected in 1860 and named for an early Lynn minister.

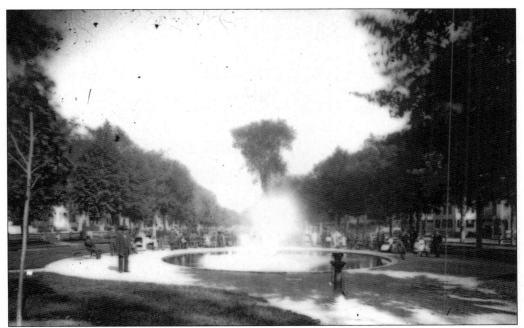

The slope of the common was increased 15 inches in 1870, and the following year the fountain and frog pond were added. The only public park in the city, it was a popular gathering place for family outings and athletic events.

The long, thin configuration of the common was defined by colonial usage, and its supposed resemblance to the sole of a shoe is probably coincidental. The path straight down the middle indicates that this is the "heel" of the footprint, or the eastern end.

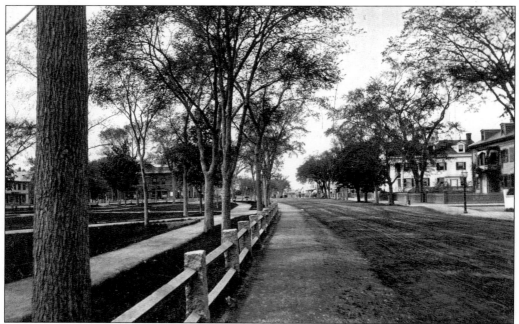

The fence visible in this view of North Common Street, looking toward Market Square, was built at the suggestion of Pres. James K. Polk, who visited Lynn in 1847. It was replaced with a wrought iron fence shortly after this photograph was taken.

At the site where the Lynn Classical High School building stands, Samuel T. Goodwin, a florist, set up shop. He had additional gardens on Grove Street.

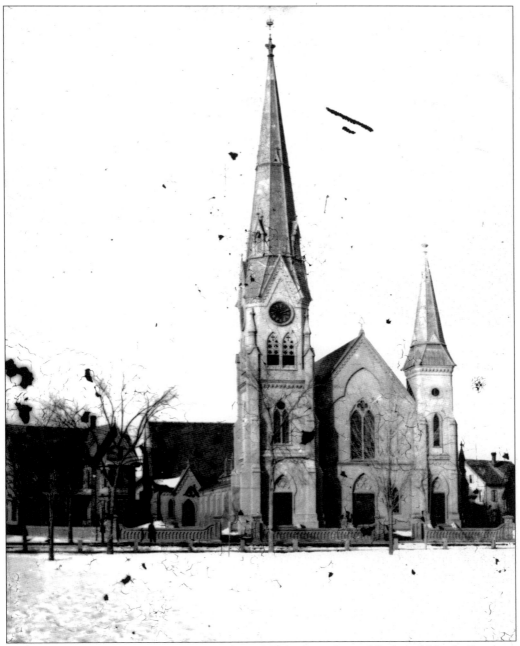

The First Baptist Church was constructed in 1867 at the corner of Park and North Common Streets. Though altered, it still stands today.

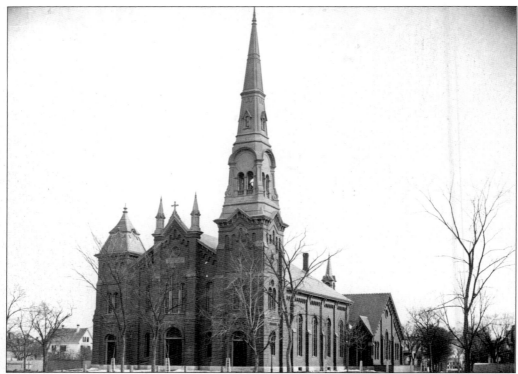

Established in 1632, just three years after the town's founding, the First Congregational Church had served as the center of both government and religion in the Puritan era. Its structure had once stood within the boundaries of the common itself. In 1870, this building at South Common and Vine Streets was built.

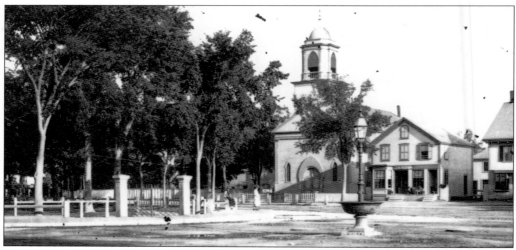

Meanwhile, the First Congregational Church's earlier colonial structure had been removed from the common, sold to the Second Universalist Society, and reassembled at South Common and Commercial Streets. This was the building affectionately known as the "Old Tunnel," not because a tunnel ever existed on its premises, but because its steeple resembled an inverted funnel; the phrase somehow became corrupted over the years.

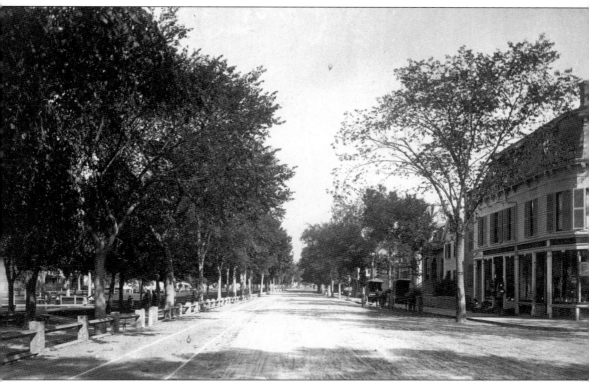

Although the area around the common had been home to numerous shoe factories in the early 19th century, by the 1870s it had become a much more residential neighborhood mixed with small retail concerns. The view here is of the south common at Shepard Street.

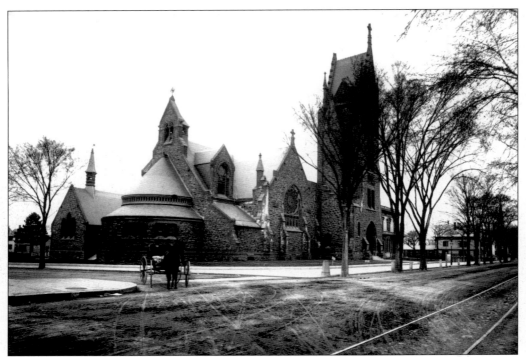

One of the finest buildings of any period in Lynn is St. Stephen's Memorial Church at South Common and Blossom Streets. It was built in 1880 and consecrated the following year as a memorial to the children of E. Reddington Mudge. Ironically, Mudge's own funeral was the first service held here.

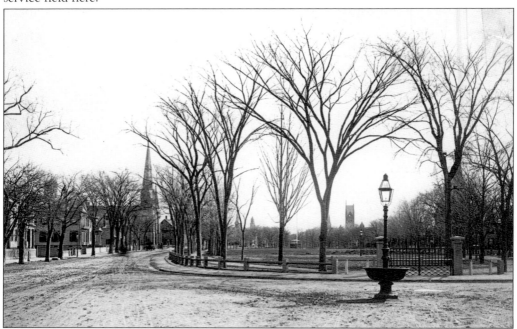

This serene view shows the common from the Market Square end.

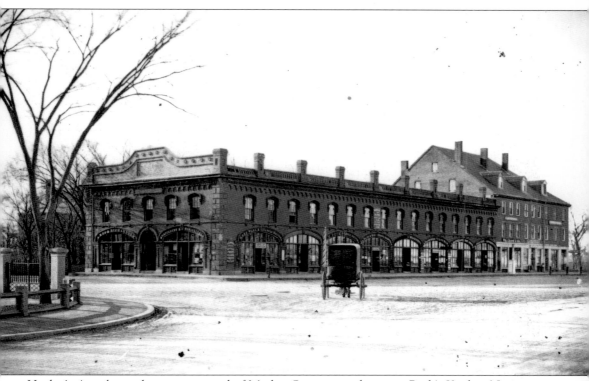

Healey's Arcade, at the common end of Market Square, was home to Peck's Yankee Notions, and Baird and Sons house painters, among others. An elaborate third floor was added to this building in 1883, and it became known as the Boscobel House, a fashionable hotel.

CHARLES E. AMES,

MANUFACTURER OF

THE ORIGINAL BELFAST

GINGER ALE,

Mineral Water,

And Tonic Beer,

ALSO, BOTTLER OF

Lager Beer, Ale, Porter, Cider, Etc.

FAMILIES AND TRADE SUPPLIED.

2 MARKET SQUARE, - - LYNN, MASS,

Also at Healey's Arcade were Ames and Richardson beer manufacturers and the West Lynn Sovereign's Association, a grocery that was one of the most prolific producers of trade cards in the city.

W. L. S. A.

CHOICE GROCERIES

26 MARKET SQUARE,

LYNN MASS.

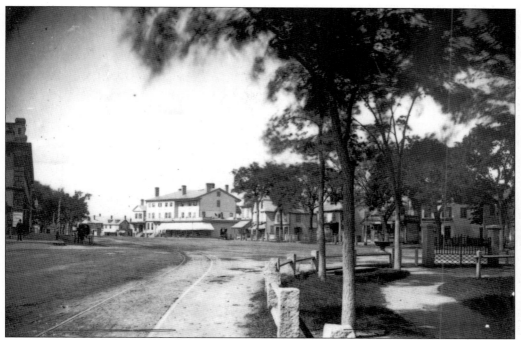

Western Avenue was created in 1803 as the Salem Turnpike, a straight route between Salem and Boston maintained by tolls. One result of the project was the development of a modest commercial center at Market Square in Lynn.

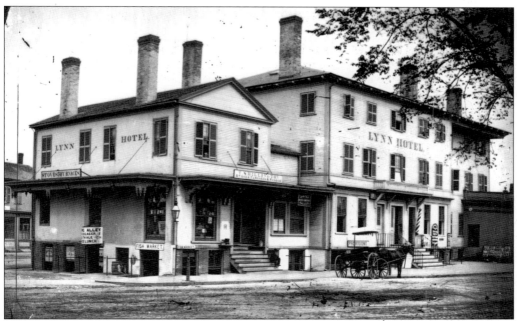

The Lynn Hotel was constructed along with the Salem Turnpike and was meant to be a moneymaker for the turnpike commissioners; it utterly failed in that respect but did remain a hotel of ever-decreasing respectability through the 1920s.

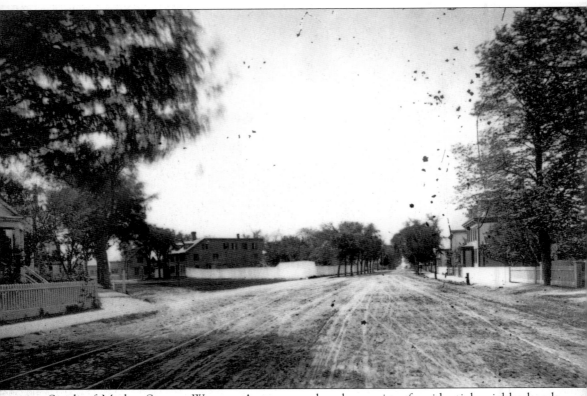

South of Market Square, Western Avenue was largely a series of residential neighborhoods easily accessible by the horse railway and the West Lynn Depot of the Eastern Railroad, not far from Breed's Square, shown above.

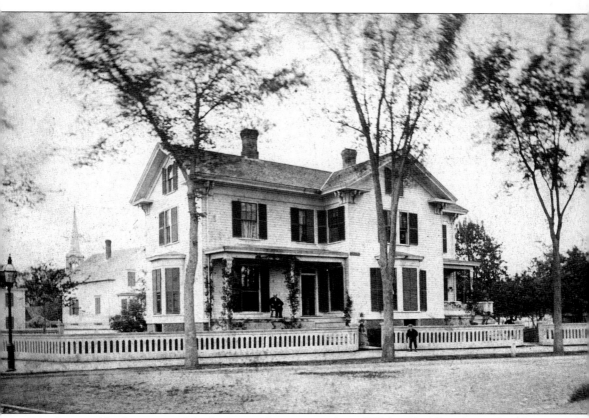

On a larger scale than most of the homes in the area was that of Walter B. Allen, located at the corner of Western Avenue and Walden Street. Allen was a carpenter and a partner in a lumber company. (Photograph by Charles E. Cook.)

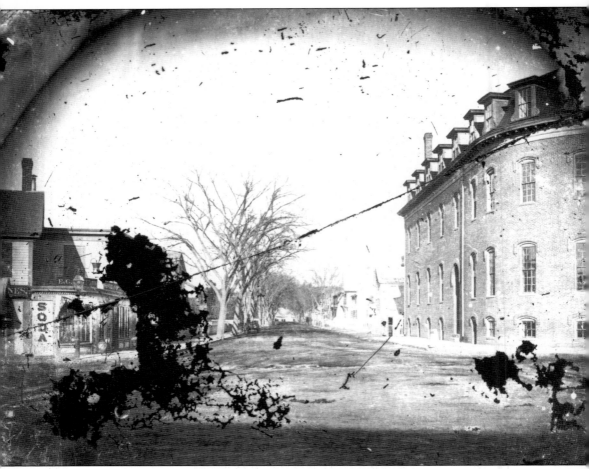

The wet-plate type of photography in use in the 1870s required photographers to apply by hand the necessary chemicals and to develop the glass plates within an hour. The thick, uneven coat of emulsion that resulted was highly susceptible to cracking and flaking as it aged, causing the kind of damage seen here in the view from Western Avenue down Federal Street. In the early 1880s, commercially prepared plates became available and largely eliminated the problem.

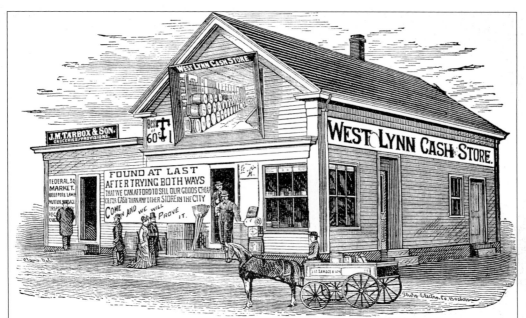

The Original and only Strictly Cash Store known in Essex County.

The WEST LYNN CASH STORE, Federal Square, Lynn, Mass.

J.M. Tarbox's West Lynn Cash Store and E.G. Bullard's apothecary occupied the corner building partially obscured on page 88.

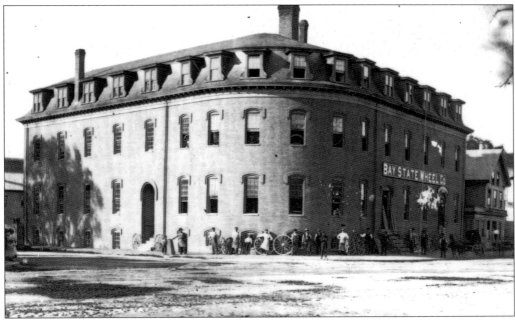

The Bay State Wheel manufactory stood at Western Avenue and Federal Street at the present site of General Electric's West Lynn plant.

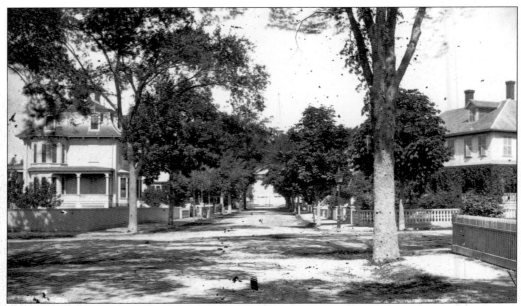

This view of Park Street from Western Avenue, with its mature shade trees and ivy-covered verandas, presents a tranquil, well-established neighborhood. The steeple of the Boston Street Methodist Episcopal Church is visible in the distance.

Josiah Heal, publisher of *Photographic Views of Lynn* and owner of the grocery store shown on page 11, lived in this comfortable home at 300 Western Avenue, on the corner of Bellair Street. Apparently, he changed his mind about going West, for he lived in Lynn and operated a grocery store at various locations until his death in 1926.

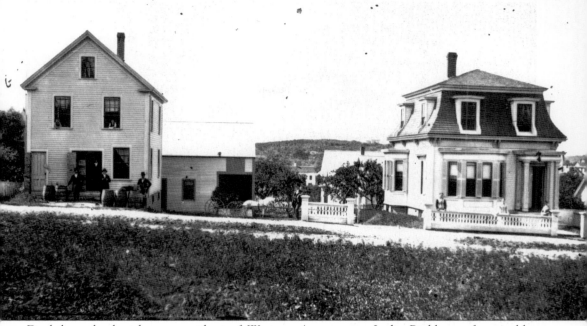

Doubtless, the best-known resident of Western Avenue was Lydia Pinkham of vegetable-compound fame. Barrels of the elixir are lined up in front of the modest wooden factory, next door to the family home. Skyrocketing sales soon necessitated the construction of the large brick facility that still stands today. The rolling hills visible in the background between the two buildings are indicative of the rural character that many outlying parts of the city still retained.

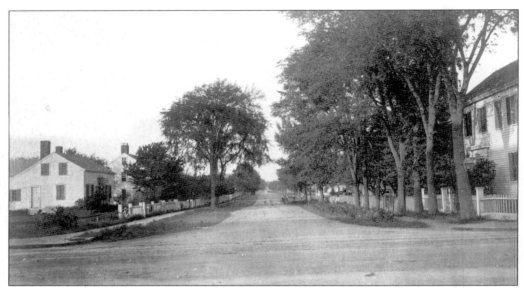

East from Chestnut Street was the neighborhood known during colonial times as Gravesend and, by the mid-19th century, as Glenmere. A number of 18th-century homes, including the George Vickery house on the right, still stood at that time.

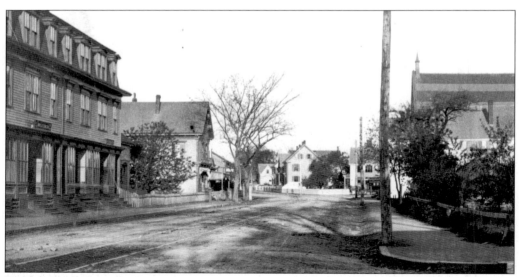

This view of Chestnut Street from Western Avenue shows more of a mix of residential and commercial buildings. The wooden block on the far left included at least one store owned by a woman, A. Conlon, a somewhat unusual circumstance for the day. Unfortunately, the nature of the business cannot be determined. The Maple Street Methodist Episcopal Church stands on the right.

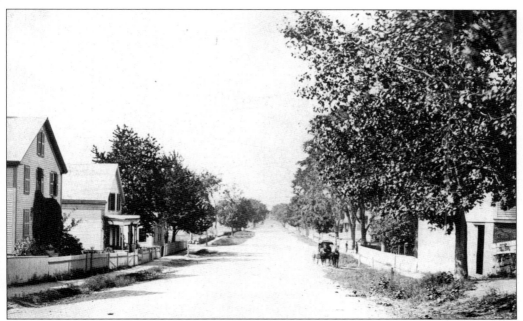

Western Avenue is shown here from Chatham Street. Much of the surrounding area was still farmland, some of it in the hands of families like the Newhalls and the Waites, who had worked the land for generations.

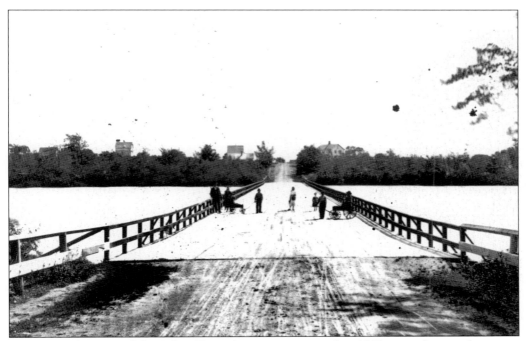

Floating Bridge, part of the Salem Turnpike, was constructed in 1803 over what was known as Collins Swamp. The swamp later became Floating Bridge Pond and is now called Buchanan Pond.

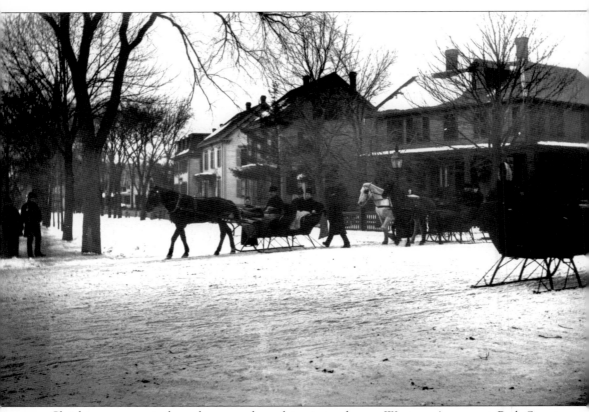

Sleighing appears to have been good on this winter day on Western Avenue at Park Street. According to many diaries of the period, the beginning of sleighing season was an event that was generally anticipated with pleasure.

Seven

SUMMER, SHEPARD, AND COMMERCIAL STREETS

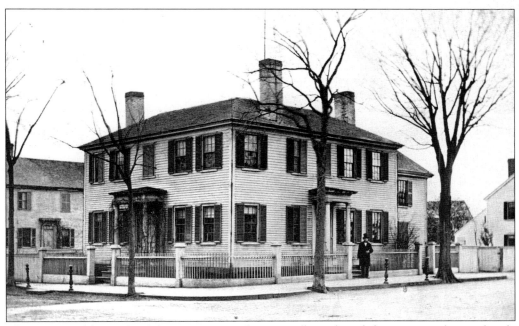

The area roughly south of the common to the water (boundary definitions vary) was already known as the "Brickyard" in the 1870s, but its essential character was transformed in the ensuing decades. Large single-family homes like the Nehemiah Berry house at the corner of Summer and Shepard Streets were replaced by 3-, 6-, and even 12-apartment tenement buildings to accommodate the growing immigrant population.

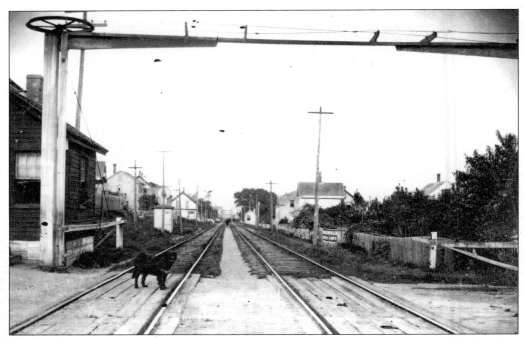

Shown here are the tracks of the Eastern Railroad at the Shepard Street crossing. The dog, presumably owned by the photographer and recorded here for posterity, begins to cross the tracks . . .

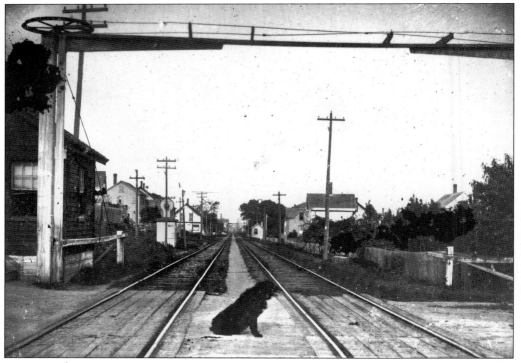

. . . pauses for a rest . . .

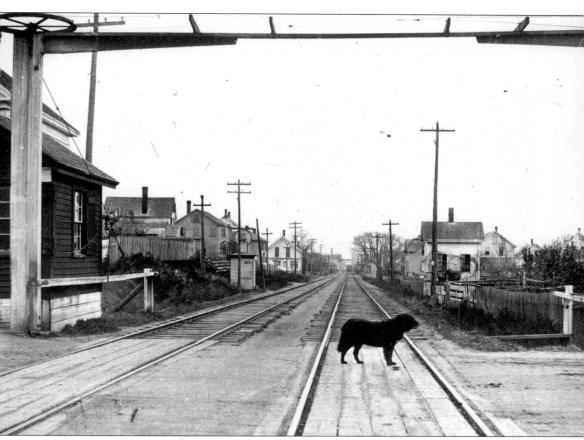

. . . and finally moves on. Different copies of *Photographic Views of Lynn* featured installments of the dog's trek across the tracks.

KIRTLAND HOUSE.

$2.00 PER DAY.

No. 34 SUMMER ST.,

Near Depots, Post Office, and Public Halls.

LYNN.

O. S. ROBERTS, Proprietor.

Converted from a private home in 1870, the Kirtland House at 34 Summer Street was a popular function hall as well as hotel. Surprisingly, from the two views shown here, it boasted 100 guest bedrooms. The bunting honors the city's 250th anniversary.

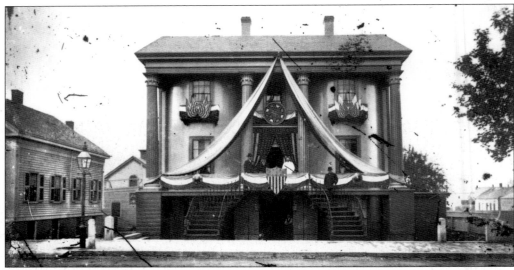

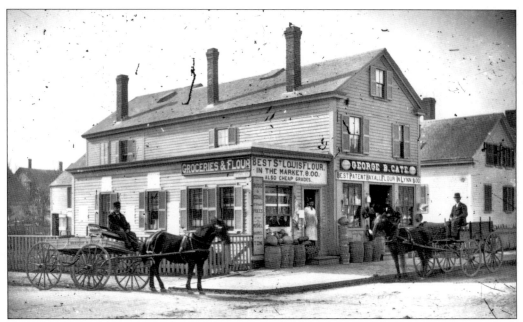

At the corner of Summer and Vine Streets was the grocery store of George B. Cate, which claimed to sell the best flour in Lynn but also offered "cheap grades." The presence of wagons in front of many such stores indicates that customers expected delivery service.

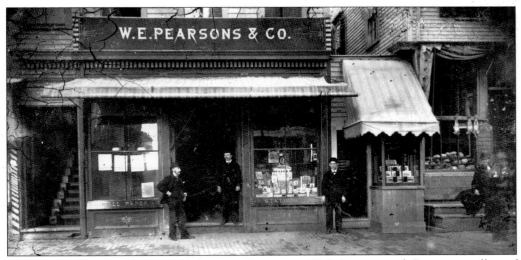

Cate's next door neighbor, at 102 Summer Street, was W.E. Pearson and Company, sellers of wallpaper and stationery.

J.E. Nichols, a fish dealer, and Stephen Marsh, a grocer, occupied space at the corner of Summer and Pleasant Streets. Like many small businessmen, both lived in the neighborhood as well, Nichols on South Elm Street and Marsh on Shepard Street.

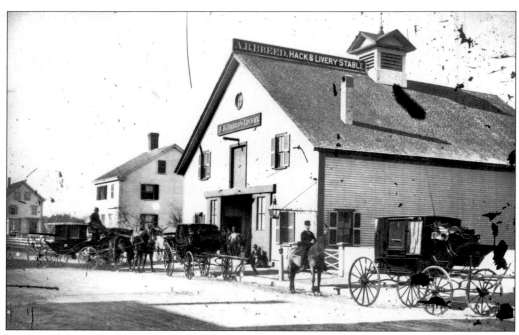

Hack and livery stables offered horses, carriages, and drivers for hire. Alan Blaney Breed operated such an establishment at the corner of Warren and Commercial Streets, one of 14 in the city in 1880.

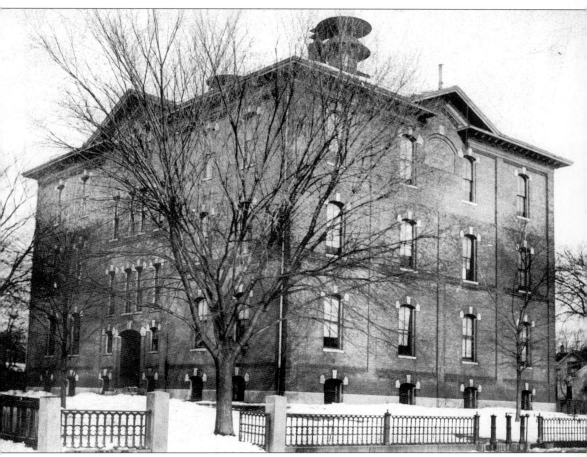

The Shepard Grammar School, named after early Lynn minister Reverend Jeremiah Shepard, was erected in 1868 on Warren Street. (Photograph by Pollard.)

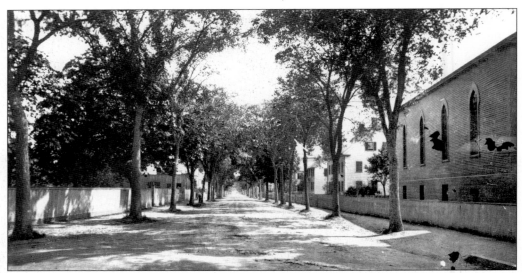

Belying its name, Commercial Street presents a quiet residential aspect in this view from South Common Street. On the right is the Second Universalist Church.

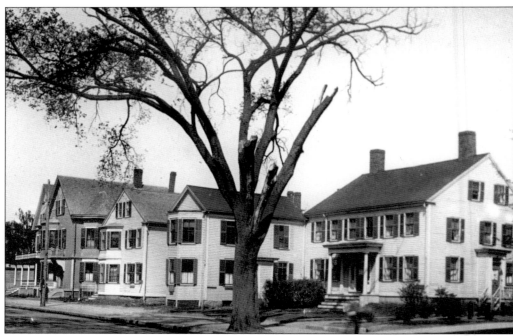

Shown here is another residential view of Commercial Street, most likely taken from Neptune Street. The house at the corner dates from a much earlier period than its neighbors, possibly as early as the 1780s.

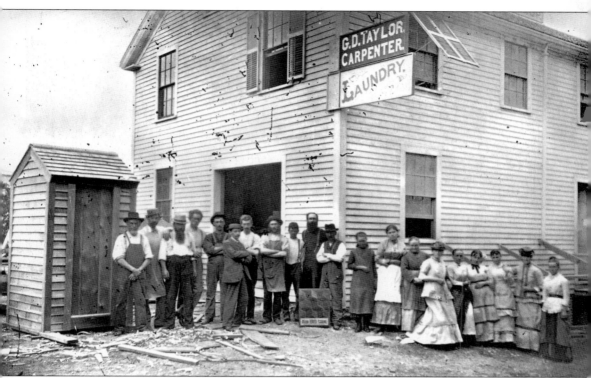

Workers from these two businesses at 61 Commercial Street may be easily distinguished by gender; the men are from G.D. Taylor's carpentry shop, and the women are from the unidentified laundry next door.

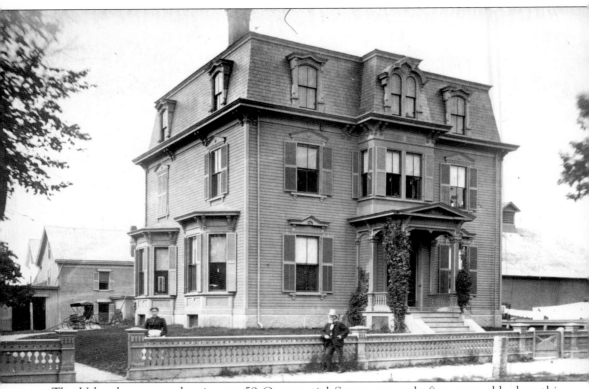

The Usher house, at what is now 59 Commercial Street, was only five years old when this photograph was taken in 1879. Usher, standing in front with a light-colored top hat, operated a grocery store not far from his home, apparently to good profit.

Eight

THE BEACHES, THE WOODS, AND BEYOND

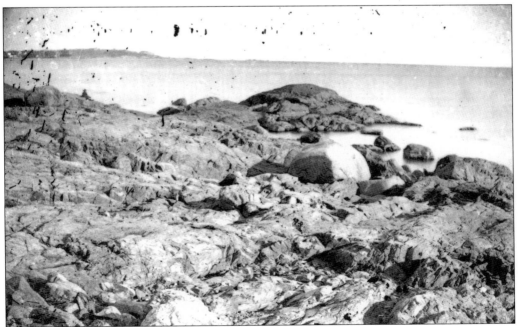

The outstanding natural feature of Lynn's shoreline is surely Red Rock. Christian Science founder Mary Baker Eddy was among the countless number of Lynners who have found inspiration at this spot.

Sliding Rock—so called because its smooth surface was used by generations of Lynn boys as an improvised water slide—was at the foot of Wave Street. In the background on the left is the barn of the Sinclair estate; on the right is the Woodbury house.

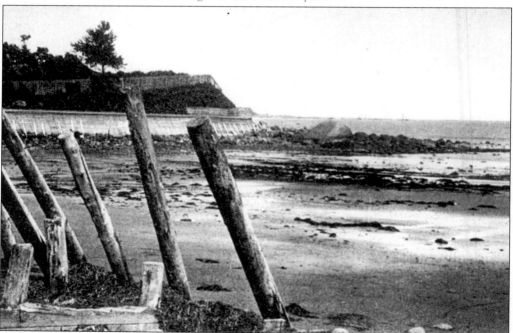

This view from the foot of Wave Street shows the size of the private estates lining Lynn's coast. The fenced-off lawn of Andrew J. Mallon's house appears in the left background; Sliding Rock is in the center.

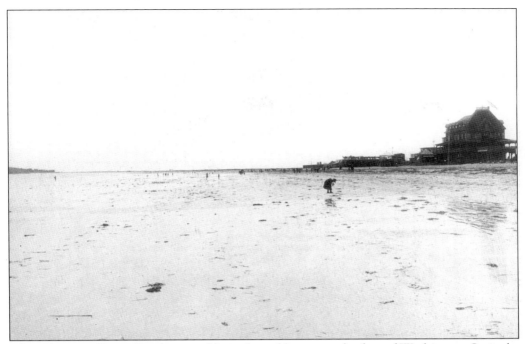

The only part of Lynn Beach accessible to the public was at the foot of Washington Street by the Nahant Causeway. In 1880, the Hotel Nahant opened, advertising itself as a "New House, Newly Furnished, 10 minutes Walk from E.R.R. station at Lynn. Horse Cars and Party Wagons run direct to the House every twenty minutes."

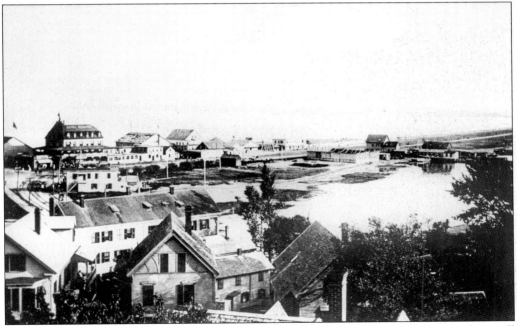

A few years later, the hotel had expanded, with the addition of a dance pavilion and a small amusement park. This photograph was taken from Sagamore Hill.

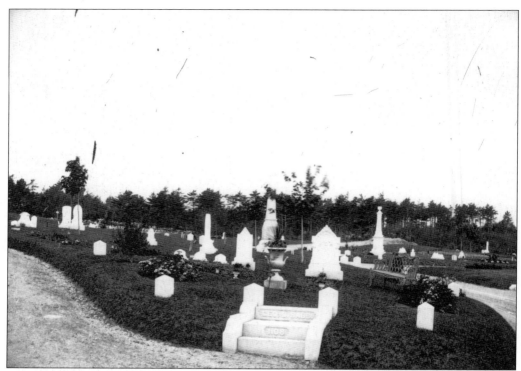

The rural cemetery movement originated in the 1840s. Mount Auburn in Cambridge, Massachusetts, was an outstanding example and the model for numerous subsequent establishments, including Lynn's Pine Grove.

Pine Grove was originally a private cemetery but was purchased by the city in 1855. The initial plan centered two circular systems around the two main elevations within the cemetery's boundaries, Mount Dearborn and Forest Rock.

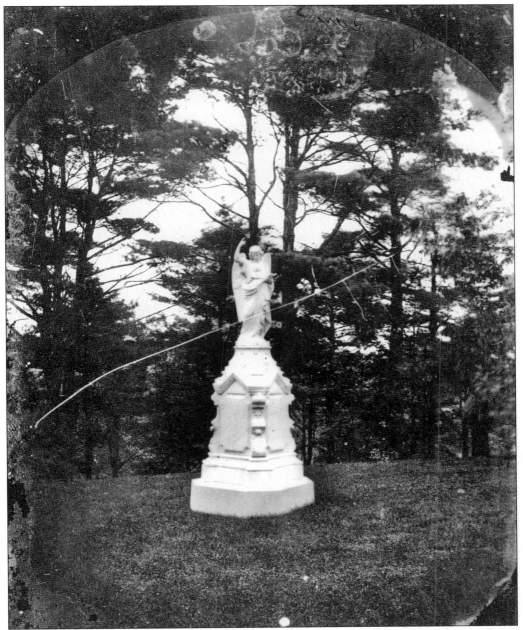

Photographic views of Pine Grove were among the most popular sold, and the Fraser collection contains numerous examples. Rural cemeteries of this kind were designed to be used by the public for quiet recreation as well as for resting places for the dead.

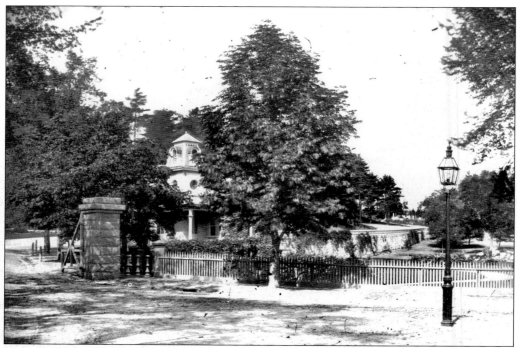

Shown here is the Boston Street entrance to Pine Grove with the gatekeeper's house, which was added in 1868.

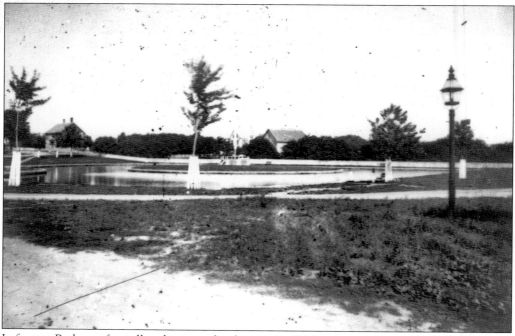

Lafayette Park was formally taken over by the city in 1870 and given the general configuration it retains today. Once known as Ingalls Swamp, the area is believed to be the homestead site of Lynn's earliest European settlers, Edmond and Francis Ingalls.

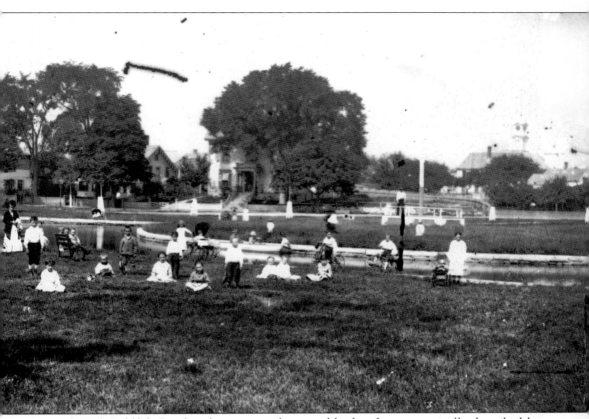

Heart-shaped Goldfish Pond and its surrounding neighborhood were poetically described by Clarence Hobbs in his *Lynn and Surroundings*, published in 1886, a few years after this photograph was taken. Hobbs wrote, "Further to the east Gold-fish Pond lies like a gem in the sunlight, while crowning the eminence which overlooks the bay are hundreds of beautiful residences, half hid among the leafy branches of the elms and maples."

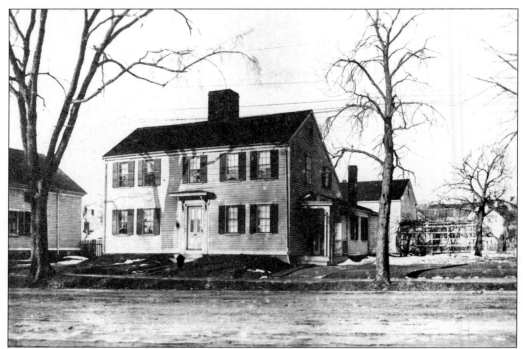

One of the oldest streets in Lynn is Boston Street; a number of very early homes still stood there as the city celebrated its 250th anniversary. The Reynolds house was built in 1775 and survived until 1960, when it was torn down to allow parking for the Lynn Hospital.

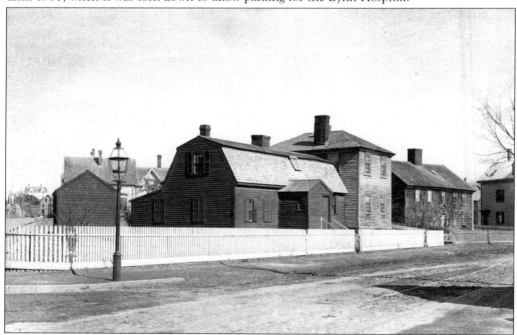

Three other 18th-century houses stood side by side between Kirtland and North Federal Streets, each displaying a distinctive style of architecture.

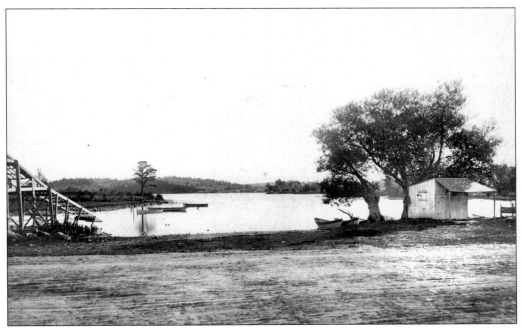

The name Flax Pond derives from Colonial days when the pond was used for soaking flax fibers before spinning them into thread. In the 1850s, Lynn poet and historian Alonzo Lewis attempted to change the name to Lake Wenuchus in honor of the heroine of a Native American legend, but it never gained widespread acceptance.

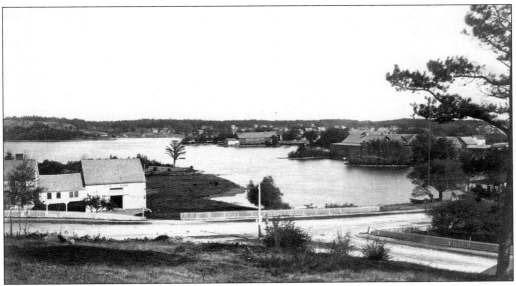

Flax Pond was an important source of commercial ice in the days before electric refrigeration. Several icehouses are visible in this view, as is the Flax Pond Hotel, which catered to sportsmen.

1879. 1879.
LYNN ICE CO.
Office 205 Union Street.

Season Rates for 1879
From May to Oct. 1st.

12 lbs. of Ice daily	$ 5.00
18 " " " "	$ 8.00
24 " " " "	$ 10.00
36 " " " "	$ 16.00

MONTHLY RATES
Commencing June 1st.

12 lbs. of Ice daily, $ 1.25 per month.	
18 " " " " $ 2.00 " "	
24 " " " " $ 2.50 " "	
36 " " " " $ 4.00 " "	

Wholesale Price.
$ 3.00 per Ton.

100 lbs., 20 cts.	50 lbs. 15 cts.
25 lbs., 10 cts.	

C. H. EDMANDS, PRES. A. H. WYER, TREAS.

(OVER)

Monthly rates for Flax Pond ice were distributed to customers by the Lynn Ice Company. The reverse side warns, "Parents will please caution their Children from riding on behind the wagons it being very dangerous."

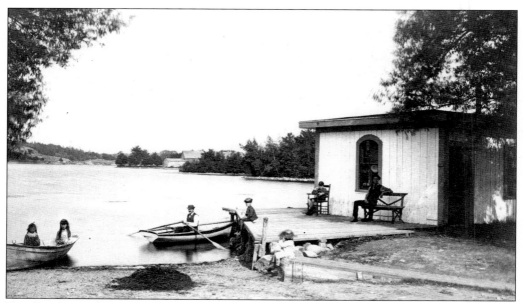

Flax Pond was also a popular spot for boating and fishing, with several rental businesses on its shores.

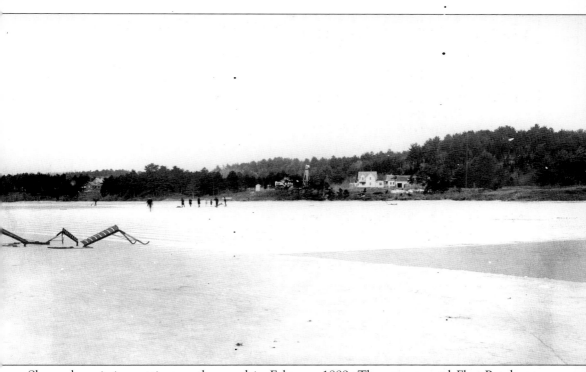

Shown here is ice-cutting on the pond in February 1889. The area around Flax Pond was relatively undeveloped at this time, home mostly to small summer cottages not designed for year-round use. The last decade of the 19th century saw significant development in the Lakeside district, which was lauded by its developers for its healthful climate.

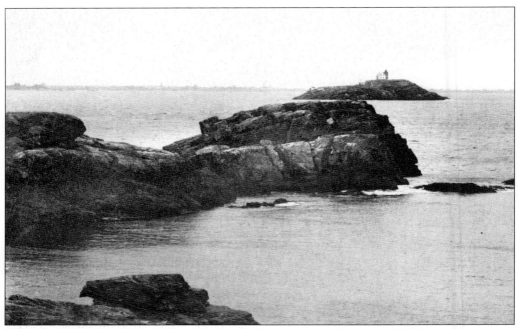

This view of Egg Rock from Pulpit Rock in Nahant shows the original 1856 lighthouse.

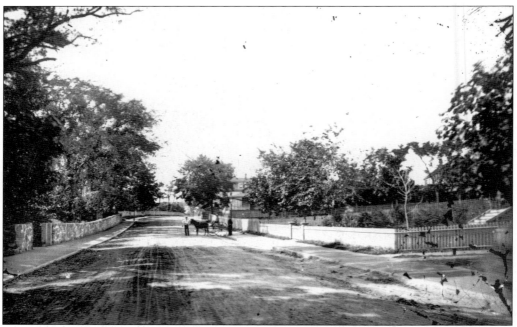

Very few of the surviving images in the Fraser collection document towns surrounding Lynn, but the close relationship between Lynn, Swampscott, Nahant, and Saugus has resulted in some inevitable overlap. This view shows Nahant Road in Nahant.

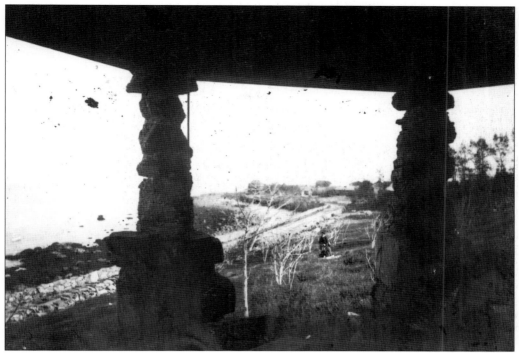

Also in Nahant, the so-called "Witch House" was actually a part of an early amusement park known as Maolis Garden, built by Frederick Tudor.

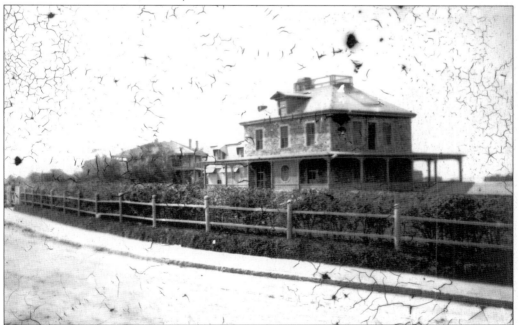

Scratched into the surface of this negative is the identification "Trimountain House," a somewhat puzzling description since it bears no resemblance to the Nahant hotel of the same name.

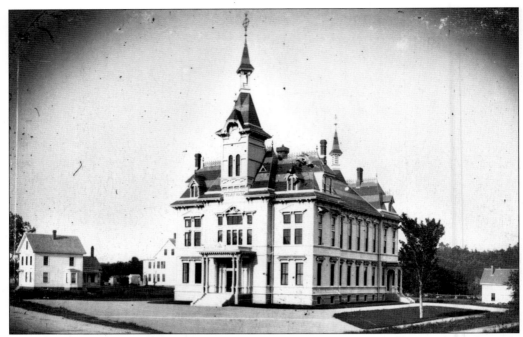

Saugus's new town hall was dedicated in 1875, a testimony to the town's growth in the years following its separation from Lynn in 1815.

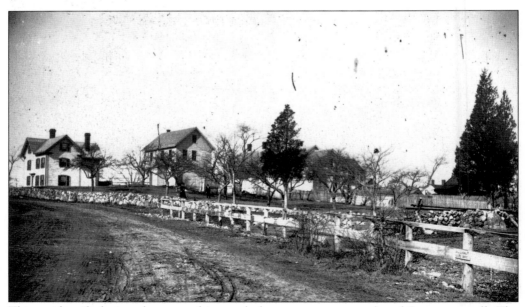

This unidentified view, because of its rural character, appears to be of Saugus as well. The Burma Shave-style advertisements on the fence are for a shoe store.

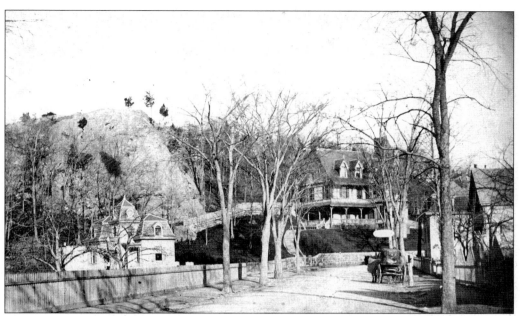

Lover's Leap, "a beautiful and romantic elevation" according to Alonzo Lewis, stands 130 feet high. The lovers in question have become somewhat obscured.

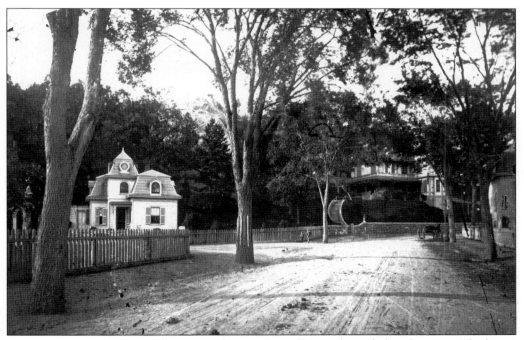

Grove Street, in the Pine Hill section of Lynn, was still sparsely settled at this time. The house on the left was the gatekeeper's cottage for the extensive estate of Phillip Tapley.

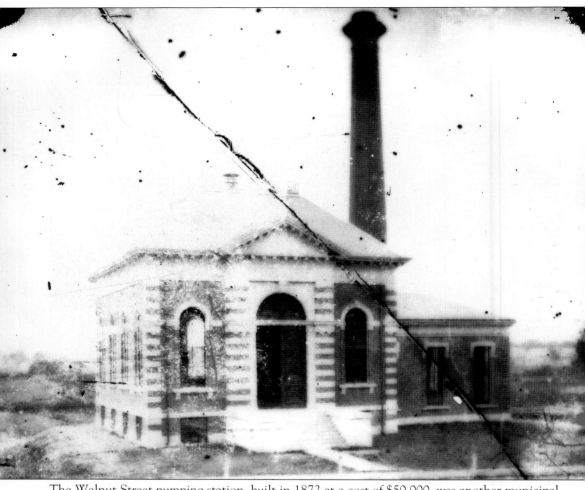

The Walnut Street pumping station, built in 1872 at a cost of $50,000, was another municipal building of which the city was justifiably proud. The city documents of that year report the following: "In view of the fact that this important public building is located just on the edge of the thickly settled portion of the city, and upon one of the highways which connects our city with some of the adjoining towns, —to be, with the pumping machinery it is to contain, the visible representative of the water-works of the city, a point of attraction to our citizens and of interest to strangers,— the large expenditure made to erect it seems to your Board justifiable."

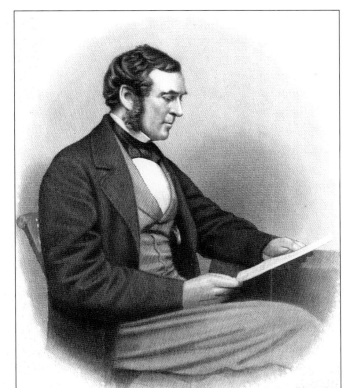

Richard Sullivan Fay, a mildly eccentric attorney and gentleman farmer, established an estate near Spring Pond, shown below, where he indulged his passion for exotic trees. His widow, who insisted upon being called "Madame Fay," was seen riding through the streets of Lynn in an elaborate coach for many years after his death. His home was at the site of the old Mineral Springs Hotel.

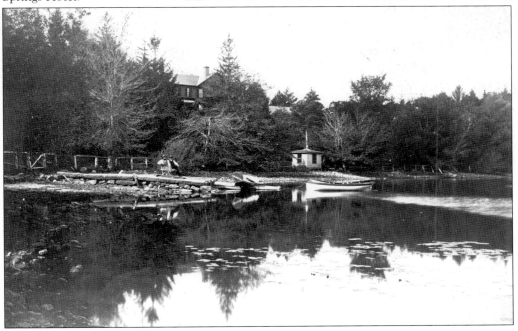

Most of Lynn Woods was still held in private hands in 1879, but movement was afoot to rectify that situation. By 1881, the trustees of the Free Public Forest had been formed for the purpose of "reinvesting the people of Lynn with their ancient, legitimate inheritance." The trustees stated the following: "The Forest of Lynn will afford every citizen a class of opportunities such as he cannot otherwise have within a distance of many miles. . . If he would walk with his children, entertain his friends, commune with nature, study her pure science, or merely rest from the glare and hurry and dust of toil and labor, the forest offers its streams and mountains, its lakes and precipices, to attract, to interest him and recreate his wearied energies; and all within the sound of his own church bell."

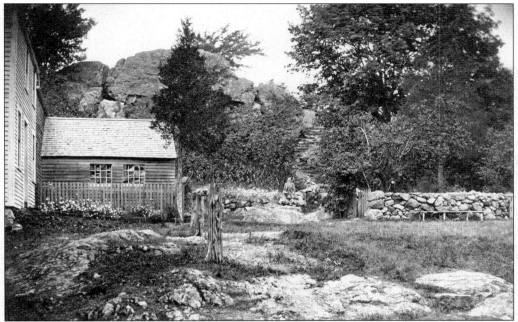

A number of private homes stood within the present-day boundaries of Lynn Woods, but the rocky terrain of much of the area left it largely unsettled for more than 200 years.

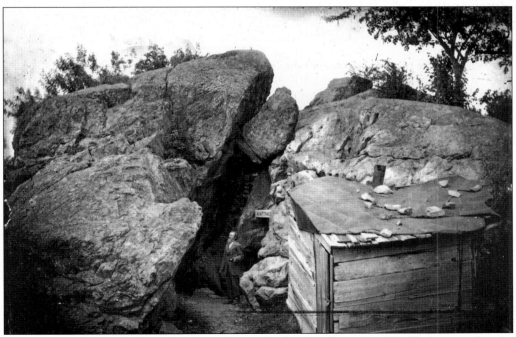

Dungeon Rock was the legendary burial site of a horde of pirate gold. Working under the direction of spirit guides, including pirate Tom Veal himself, Hiram Marble and later his son Edwin, shown here, spent years unsuccessfully excavating the area.

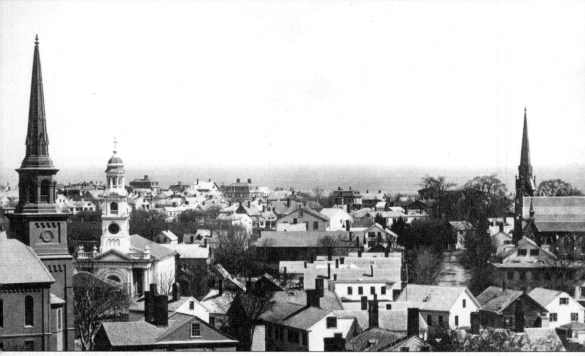

This full 180-degree view of the city, here looking east, was taken at the most popular viewing spot in Lynn: High Rock. Shown here, from left to right, are the steeples of the High Street Baptist Church, the East Baptist Church on Union Street, and the Central Congregational Church on Silsbee and Mount Vernon Streets.

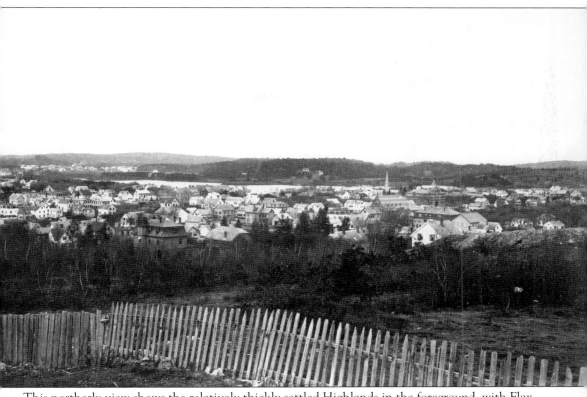

This northerly view shows the relatively thickly settled Highlands in the foreground, with Flax Pond and still-rural Lakeside beyond.

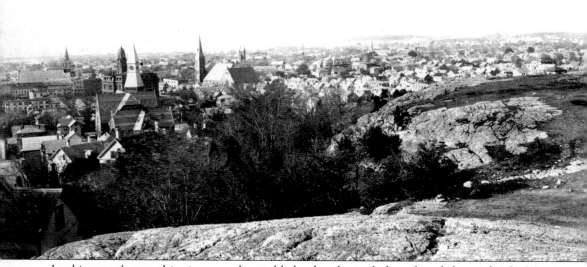

Looking southwest, this view reveals notable landmarks, including, from left to right, St. Mary's Church, city hall, the Washington Street Baptist Church, and the First Methodist Church.

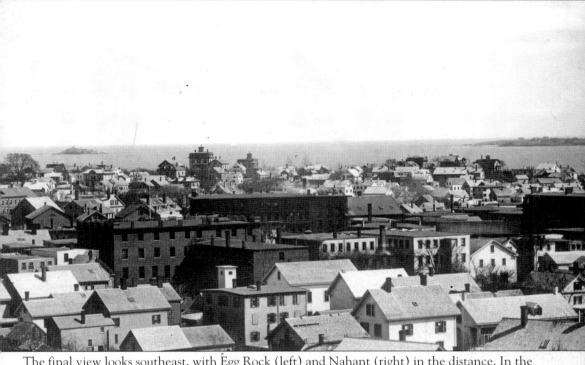

The final view looks southeast, with Egg Rock (left) and Nahant (right) in the distance. In the foreground is the rear of the Sagamore Hotel on Union Street, and on the far right is the A.F. Breed Shoe Factory.

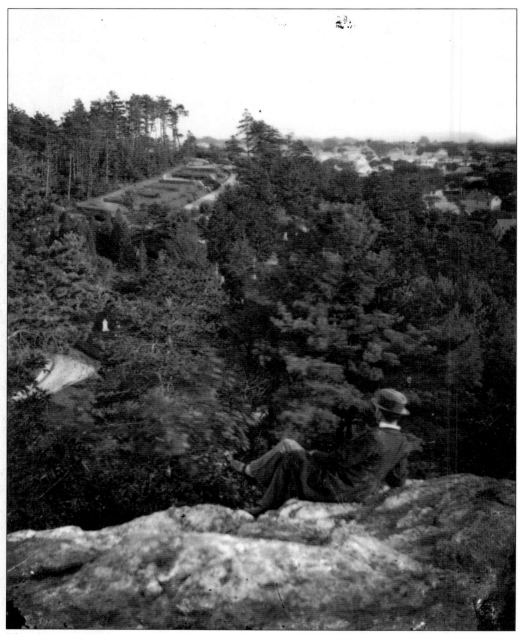

The photographer has scratched the words "from prospect rock" into the glass negative but has left a mystery as to where that might have been.